LIGHT & POSE

Master the Secrets of Wedding and Portrait Photography

Rick Ferro

AMHERST MEDIA, INC. BUFFALO, NY

AUTHOR A BOOK WITH AMHERST MEDIA!

Are you an accomplished photographer with devoted fans? Consider authoring a book with us and share your quality images and wisdom with your fans. It's a great way to build your business and brand through a high-quality, full-color printed book sold worldwide. Our experienced team makes it easy and rewarding for each book sold—no cost to you. E-mail **submissions@amherstmedia.com** *today!*

Published by:
Amherst Media, Inc., PO Box 538, Buffalo, NY 14213
www.AmherstMedia.com

Publisher: Craig Alesse
Senior Editor/Production Manager: Michelle Perkins
Editors: Barbara A. Lynch-Johnt, Beth Alesse
Acquisitions Editor: Harvey Goldstein
Associate Publisher: Kate Neaverth
Editorial Assistance from: Carey A. Miller, Sally Jarzab, John S. Loder, Roy Bakos
Business Manager: Adam Richards

ISBN-13: 978-1-68203-080-6
Library of Congress Control Number: 2016938430
Printed in The United States of America.
10 9 8 7 6 5 4 3 2 1

www.facebook.com/AmherstMediaInc
www.youtube.com/AmherstMedia
www.twitter.com/AmherstMedia

CONTENTS

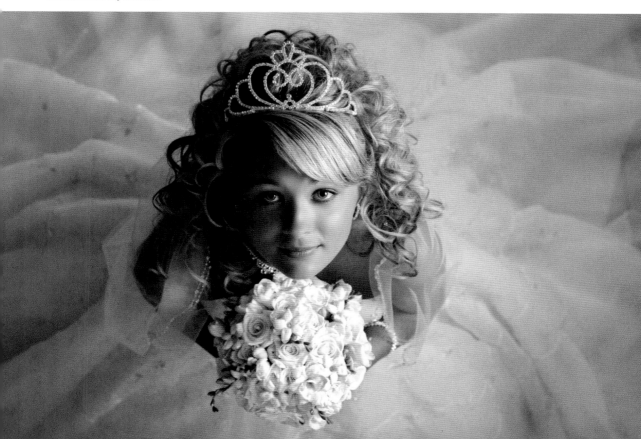

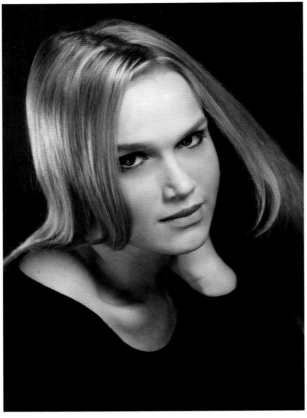

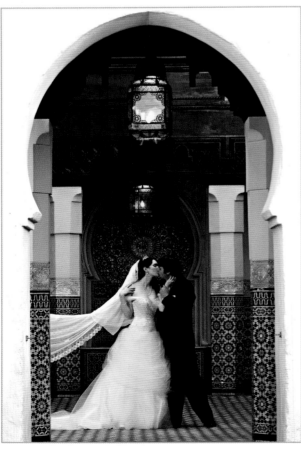

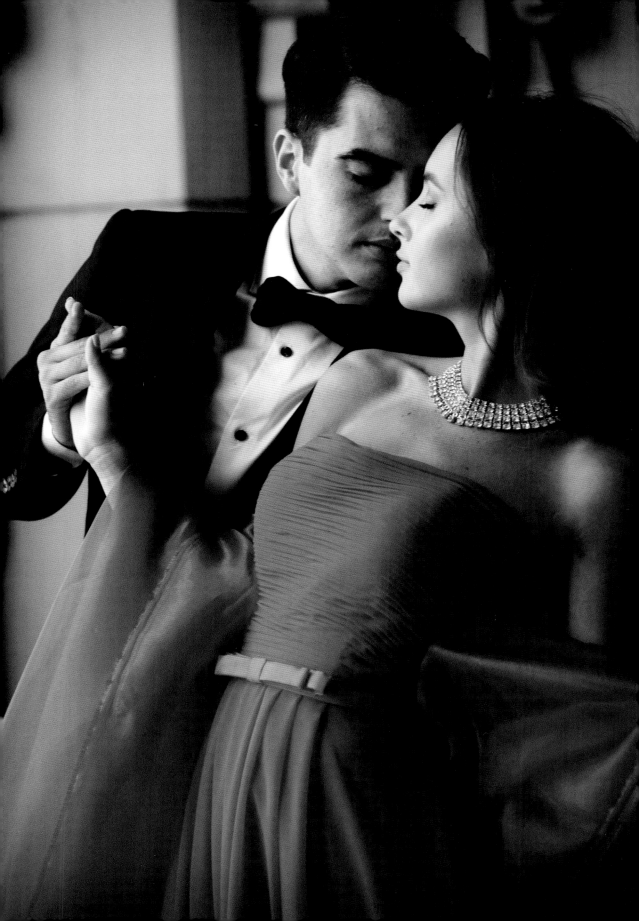

ACKNOWLEDGMENTS

Thank you to: Phottix.com, Ztylus.com, Amherst Media, Lucis Art Pro, and Triple Scoop Music. A special thanks for their contributions to: Patty Bradley, Amy Alexander, Mike Strickland, Michelle Perkins, Ana Montgomery, Jerick Carino, Megan Plock, Gloria Dorming, Beth DeMund, Deborah Lynn Ferro, NIK Filters, and Adobe Photoshop.

DEDICATION

In my last three books with Amherst Media, I have always wanted to thank my Mentors Don Blair and Monte Zucker.

To me, a mentor doesn't have to do anything with photography or the business I'm in. A mentor is someone who has helped you unconditionally and given support throughout your life in many different ways. My wife is one of those people—someone I look up to and someone who has loved me unconditionally! She has always supported me, whatever I chose to do.

I also have been fortunate to have another special mentor I wanted to add to this dedication. His name is Bill Hurter; he was a very special friend, always trying to give his help in any way. Bill was the editor of *Rangefinder* magazine, but as busy as he was, he would always take time to stop and help if you needed it. Bill has now passed on but he left behind a true legacy! He was an industry leader and will be missed dearly. Keep writing those books in heaven Uncle Bill!

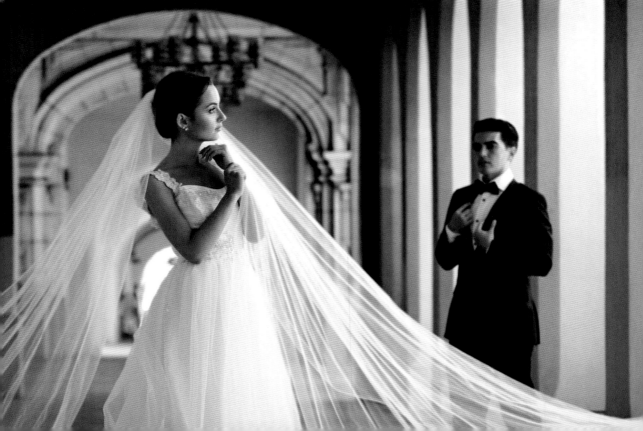

ABOUT THE AUTHOR

Rick Ferro is a PPA-certified Master Craftsman and has been a proud member of that group for many years. In 2006, he was honored with the Photography Service Award at the United Nations in New York City.

From 1993 through 1996, he helped develop the wedding photography department for the Walt Disney Corporation in Orlando. In 2009, after running a successful wedding photography business of his own, he came back to Disney as a contractor and now continues to work for the Disney Fine Art Production Company, training new photographers and photographing high-end weddings.

Rick is the author of several books for professional photographers and a writer for the highly acclaimed website Shootsmarter.com, which reaches over 145,000 readers every month. He has also produced eight educational videos for Quantum Instruments.

In addition to wedding photography, Rick has done commercial photography assignments for the Miami Dolphins, Pepsi, and Mercedes Benz—to name just a few.

He teaches worldwide and his workshops in Jacksonville, Florida, have helped aspiring photographers, young and old, for years. Rick has recently finished an extensive teaching tour that took him throughout Europe and the United States. He specializes in teaching the art of romantic portraiture, hand posing, and lighting.

Rick has many sponsors to his credit, including Phottix, Ztylus, ACI Lab, Queenberry Album Co., Triple Scoop Music, and Alien Skin Software.

INTRODUCTION

Because I teach all over the world, I am lucky to be able to listen and talk to many photographers—both experienced pros and newbies.

In all my conversations, I always get the same questions! Like:

- How do you get your exposures so right on the money?

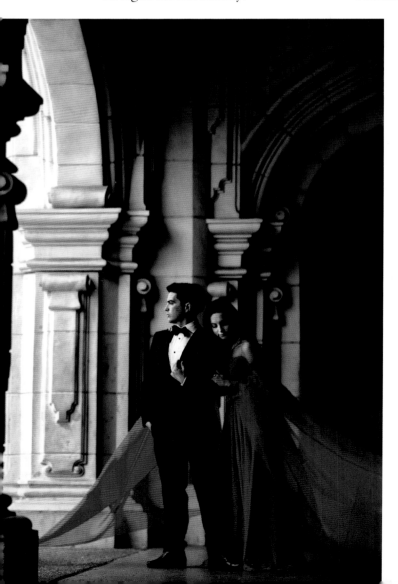

- I'm not comfortable with posing. Do you have any tips?

- What's the best lighting for portraits—LED or flash?

The list goes on and on! So rather than put together another book centered on wedding photography, I decided to do something a little more broad and write a book that answers these questions, looks and what's new in our industry (like LED lighting), and helps photographers make better decisions about what lens to use and how to set the stage for perfect portraits in the studio or on location (and, yes, I will cover weddings, too!).

Before I started to write this book, I also picked up a few new ideas from many other talented photographers. Some of them appear as contributors in the following chapters.

66 I am lucky to be able to listen and talk to many photographers— both experienced pros and newbies. 99

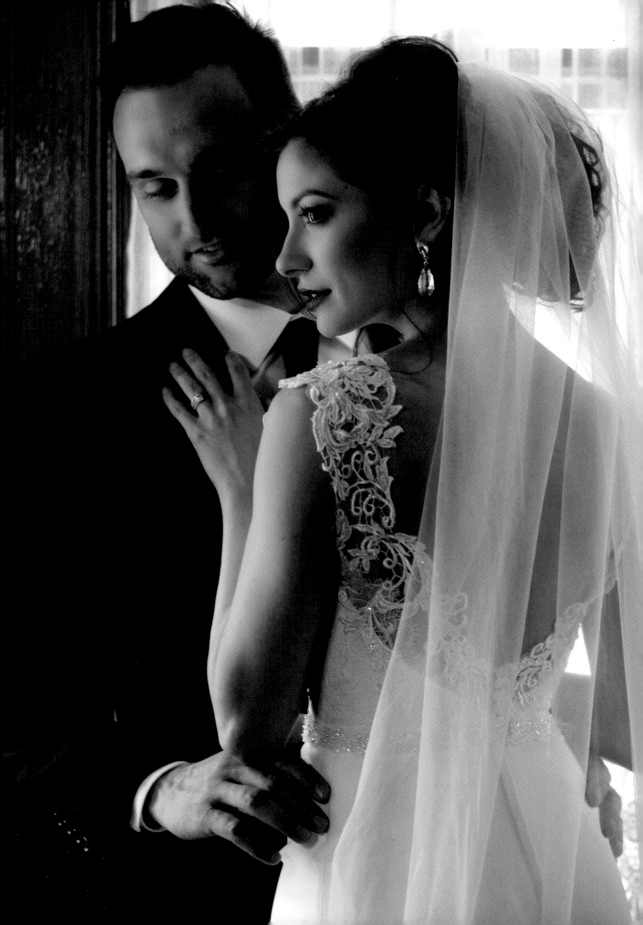

1. VEIL AS BACKDROP

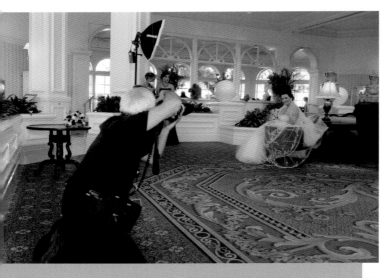

The most important skill you can have as a photographer is the ability to create exciting, high-impact images wherever you are. I don't always have great locations to choose from, so this is a technique I like to use in bridal portraiture. It's a simple and beautiful look that never fails to please the bride.

SETUP

To get the shot, you may need some help. I have my assistant get behind the bride and carefully hold up the veil. Another approach would be to use a backdrop stand to support the veil and use clips to carefully hold it in place. For the sequence seen here, I actually enlisted a couple of the bridesmaids to hold up the veil. (And if the bride doesn't have a veil, the train of her

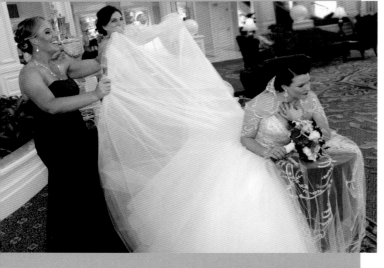

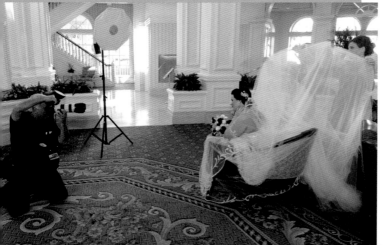

❝ The most important skill you can have as a photographer is the ability to create exciting, high-impact images wherever you are. ❞

dress might work for the same effect!)

LIGHTING

The main light should always be positioned at approximately a 45 degree angle to the face and be high enough to minimize any shadows. Fill light is also important. If you are working with only one light, it can be hard to control the harsh shadows on the subject's face. Adding a second light or a soft white reflector to open up the shadows will produce a more flattering look.

I use my lights in manual mode to allow me total control over the lighting ratio (the difference between the highlight/shadow exposures) on the subject. This control is especially important when shooting digital, which is less forgiving than film.

EXPOSURE

When working outdoors, my ISO is usually set at 100 or 125. I always try to shoot wide open, so whatever the meter says in the ambient mode is what I'm going to use. That usually means setting my main light at $\frac{1}{4}$ power in manual mode; I don't need a lot of power. The fill light should not be at the same intensity as the main light, so I usually adjust it to $\frac{1}{8}$ power in the manual mode.

2. MAKE MONEY WITH ENGAGEMENT PORTRAITS

CONTRIBUTOR: Deborah Lynn Ferro

Having the opportunity to photograph a couple prior to their wedding has tremendous financial potential for you as a photographer.

First of all, you have the opportunity to build a relationship with the couple when they are in a relaxed state and not dealing with all the stress that they are confronted with on their wedding day. Even the most reluctant groom warms up if you are willing to be creative in the locations you choose and offer them an atmosphere that is fun and relaxed. This will set the entire mood of the wedding.

Even if you have not booked the client's wedding, doing their engagement first gives them a chance to try you out without the commitment, while giving you the opportunity to sell them on your talent and skills as a professional. It also is an opportunity to offer incredible products from the engagement session while increasing sales for you.

The majority of couples that are getting married today are much older than the couples ten to twenty years ago. They are established in their careers and have the finances to purchase their first home before having children. Even if the parents are paying for the wedding, the couple usually has their own money to contribute or add to the photography.

We offer a line of products from the engagement session that can be displayed

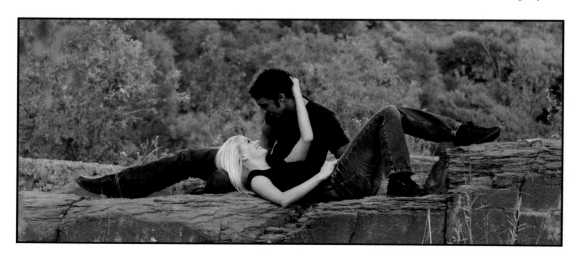

all year in the client's home. We find that the majority of our clients would rather have a beautiful portrait from their engagement session displayed in their home than one from the wedding.

BRIDAL SHOWS

One of the first ways to get a lot of engagements is from bridal shows. Some key factors when doing a bridal show are to have the best of your work displayed in frames. You will also want to have several sample wedding albums on display for brides to look at. We have used Renaissance Albums

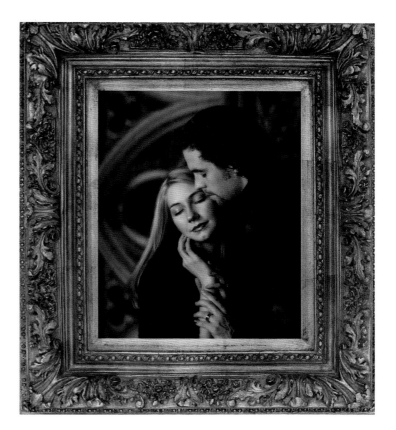

and Queenberry for all of our traditional and flush mounted wedding albums. Their phenomenal products are a draw for us at bridal shows.

Make sure that you, the photographer, are there to meet with the brides so that you can initiate a relationship with them. This will also help you determine which weddings you will choose to follow up on for booking.

We feel a crucial element at a bridal show is to have a drawing. Have a ballot box to display where brides can enter to win something of value. We give away a *free* engagement session and a 16x20-inch framed print. When you have an example of the 16x20 framed engagement image on an easel by the ballot box, brides

will sign up all day long. Make sure you require e-mail as well as a phone number and address on your ballots so that you can follow up later. Even if the bridal show sends you the bridal contacts, having a "Register to Win" drawing will attract brides to your booth and give you the opportunity to talk with them.

We do not spend a lot of money on a brochure or cards that are given out at bridal shows because half the time they are thrown in the trash. A bride will take your marketing piece and toss it in a bag. When she gets home, she'll dump everything out on her bed and choose the ones she likes. However, there will be a select number of brides to whom you will want to give something more impressive. You can give

it to them at the show or follow up and mail it to them later.

FOLLOW UP

Good follow-up practices are critical after an event like a bridal show. We might have 350 leads from a bridal show, but maybe only thirty of those leads are the type of client that we are looking for. We follow up with every bride (all 350 of them) through Constant Contact. To those thirty select brides who are our target customers we also send a custom card from Send-OutCards, an Internet-based greeting card company. SendOutCards allows us to create a custom photo 5x7-inch card, called a campaign, and send it to all thirty contacts at once for under $1 plus postage (per card). The system will personalize every card and address every envelope. We put an engagement photo on the front

of the card and then on the inside we tell all thirty brides that they have won a free engagement session. You can try a card for free at www.sendoutcards.com/ferro.

Only one bride wins the 16x20-inch image from the drawing, but the select thirty who have yet not booked a photographer and are the type of client that we are looking for all win the session. Why? We know that photographing their engagement helps us build a relationship with the client and allows them to see first hand the quality of our work. The only requirement for the couple is that they have to do a bridal consultation within two weeks of receiving the card, which gives us the opportunity to meet with them right away about their wedding. We tell them this also gives us the opportunity to show them examples of engagements at different locations and discuss appropriate clothing for their session.

Once the engagement session is done, it is time to schedule the client's viewing appointment. As soon as we are back from doing their engagement session, I retouch one of their images, upload it to the front of a SendOutCards card and send them a card that thanks them for giving us the opportunity to photograph their engagement

and confirms the time and date of their viewing appointment. This wows them before they even come in for the viewing appointment and gets them excited to see more of the images from the session.

BANNERS

Photographers often use banners at bridal shows. Why not offer to sell the couple banners from the engagement session as displays for their rehearsal dinner or to be placed at the entrance of the reception hall? Your lab can custom design a banner for you or you can send them your design. These banners have canister bases that make it easy to store the banner and just pull it up for display.

WALL PORTRAITS

We offer a 11x14-inch Signature Folio from our lab instead of a Signature Board that takes up a lot of wall space. This leaves the door open to sell a large canvas. From a traditional framed canvases to the new gallery-wrap giclée canvases, our lab

❝ Why not offer to sell the couple banners from the engagement session as displays for their rehearsal dinner or to be placed at the entrance of the reception hall?❞

offers a variety of finishes. Because of the humidity in Florida, we prefer a canvas on Masonite board as opposed to a stretched canvas. In order to sell canvas wall art you have to display it. Clients will generally choose a size in the middle range of what you show. So show *big*!

STORYBOARDS

The great thing about offering a storyboard in a panel frame, or a digital format, is that it tells the love story of your clients and presents it in a way that provides beautiful décor for their home. Offering these products has made selling frames easier and increased our sales. Our clients also love to display their storyboard framed print at the reception.

SLIDE SHOW PRESENTATIONS

Even though we have the ability to make our own slide show presentations, we cannot sell them unless we use royalty-free music by Triple Scoop. Our money is made behind the camera, not doing these presentations. We do a slide show with music on DVD from the engagement session; this is designed for the couple to show at the rehearsal dinner or to loop at the wedding reception. It can be viewed on a television and enjoyed for years to come.

ON-LINE PURCHASING

Don't miss the opportunity to sell beyond the initial sales appointment. We offer to put each client's images on-line for free

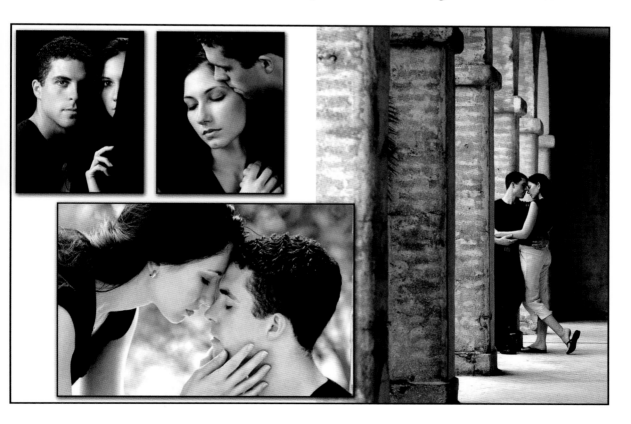

Rick's Tips for Successful Engagement Portraits

The engagement portrait session is usually the first time you will be working with your new clients. It's a time to build a good rapport and make them feel good about themselves.

Teach Posing. In addition to preparing them for what to expect during the photography on the wedding day, you can also instruct them on the basics of posing for photographs. This will make things go more quickly on the wedding day—meaning that the couple can get back to their guests more quickly and maybe even attend the cocktail hour (if so desired).

Plan the Clothing. Unlike on the wedding day, when the bride's and groom's clothes are pretty much predetermined, the couple will need to select their own outfits for the engagement session. Advise them as you would portrait clients (see next section) and remember that coordinating outfits will make the two really look like they belong together.

Think About Style. Discuss whether the couple prefers a studio or location session and a formal or casual look. Ask them where they want to display the portrait and think about ways to design an image that will perfectly suit that use.

Share Your Work. After the session, don't forget to share your best images on social media and tag the couple. Sites like Facebook, Instagram, and Twitter can really help photographers—I'm always posting images on-line and definitely find that it generates business.

with a $400 minimum purchase. Your best sales will be when you have the client in front of you while they are seeing the images for the first time and when there is emotional impact—but the on-line sales to family and friends can also be huge. Imagine making money on-line while you're sleeping!

> 66 Ask them where they want to display the portrait and think about ways to design an image that will perfectly suit that use. 99

GREETING CARDS

I have already discussed how we follow up with our clients using SendOutCards. This is also a great program for creating "save the date" cards, thank-you cards, and holiday cards. We give our clients an incentive to sign up for SendOutCards. If they sign up in SendOutCards under us (www. sendoutcards.com/ferro), we offer to copy over ten photo cards for them to use from their wedding. You can copy over photo cards into the system for free, to any user, but they cannot print it as an image; they can only use it as a greeting card. Imagine their options—an engagement image for a "save the date" card, a wedding image for their thank-you cards, sending the bridal party a card with their picture on the front and a gift card enclosed as a thank-you for being in the wedding. (Yes, the SendOutCards system even allows you to add gift

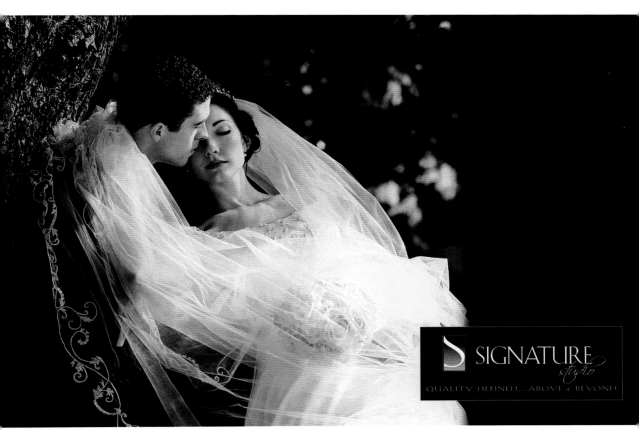

cards for gifts!) I make this offer to them because we make money when they sign up and on every card they send out using the system. It has improved our customer service and increased our marketing potential. The SendOutCard system also reminds me of all my customer's birthdays and anniversaries. This has saved us time and money and changed the way we do business.

THE MARKETING COST

Is it worth spending less than $10 to book a wedding that could bring you thousands of dollars or give you sales of over $1500 from the engagement session? You have to spend money to make money.

Shop where your client shops and look at how other businesses market and sell to their clients. If you want to obtain a client who shops at Saks Fifth Avenue or drives a Mercedes, then you have to be in that mind-set when marketing. Image is everything. Go out and make more money from engagements—and have fun!

66 If you want to obtain a client who shops at Saks Fifth Avenue or drives a Mercedes, then you have to be in that mind-set when marketing. 99

3. CLOTHING SELECTION

We always start out by telling our clients what *doesn't* work for clothing. First and foremost, we ask them to avoid wearing prints (stripes, plaids, etc.) and not to include clothing with logos. Additionally, I let them know that black and white clothing will usually create exposure problems (unless the session is going to be in the studio).

If the session is going to be shot at an outdoor location—at a beach, or in the woods, or by a river—I let them know that browns and jeans are perfect. Earth tones bring out the skin tone nicely.

Additionally, I always ask them if they are thinking about a large portrait—and, if so, what room they are planning to hang it in. Thinking about the colors in that room can make the clothing choices obvious (and this conversation sets you up to make a large sale!).

If you don't prepare your clients, you're going to have surprises. It's better to be totally honest *before* you shoot.

4. A NATURAL LIGHT LOOK

CONTRIBUTOR: Amy Alexander

From concept to creation, this image was a long time in the making. It was photographed against a tiny patch of wildflowers on the side of the road. Every so often, this area gets mowed—so you have to catch it in the right season, at the right time of day, and in the right conditions. There was just a small window of opportunity, so I knew that if I didn't seize the moment I would have to wait until next spring to create the image I had in mind.

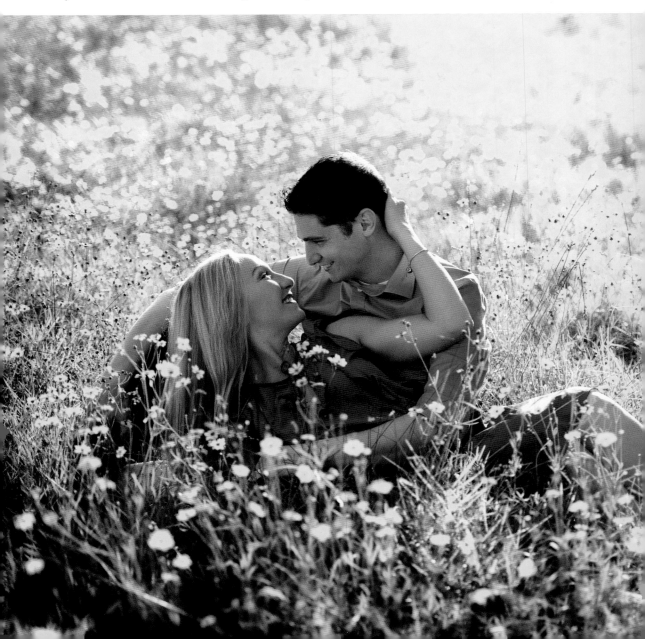

When the opportunity presented itself, I gathered my friend Rachael and her husband Rick. I had the opportunity to photograph them for their anniversary, so I used a pose from their previous session as the inspiration. From that foundation, I began to build the look I was going for.

The vision I had was very light, airy, and of course romantic. If you remember the *Twilight* films, you might recall the gorgeous field where Bella and Edward kiss; that's the look I wanted to bring to life.

I scheduled an early morning shoot, around 8AM, in order to have the sun to their backs and not too high in the sky. It provided me with hair light and enough ambient light to keep the softness I was looking for in the faces. I choose an area in the patch of flowers that was full but still had enough spacing to let them sit and not crush everything.

> 66 I knew that if I didn't seize the moment I would have to wait until next spring to create the image I had in mind. 99

I used Adobe Photoshop and Nik Color Efex to add my final touches to the image. The image was shot on a Nikon D810 camera with a 70–200mm f/2.8 lens. The exposure was made at f/2.8, $^{1}/_{500}$ second, and ISO 200 using only the available light.

Amy Alexander has worked for Disney Fine Art Photography for fourteen years and is a seasoned professional who shoots anywhere from 150 to 200 weddings a year.

5. PETS IN COUPLE PORTRAITS

What's better than this? We all do family sessions with clients who want their pet or pets included in the images. I have to be honest about this image: it was shot while I was out teaching in California. I was posing this stunning couple when a beautiful dog and its trainer approached us.

This class was on profile poses with the couple (using window light or available light). So, rather than change what I was doing, I had the trainer put the dog into

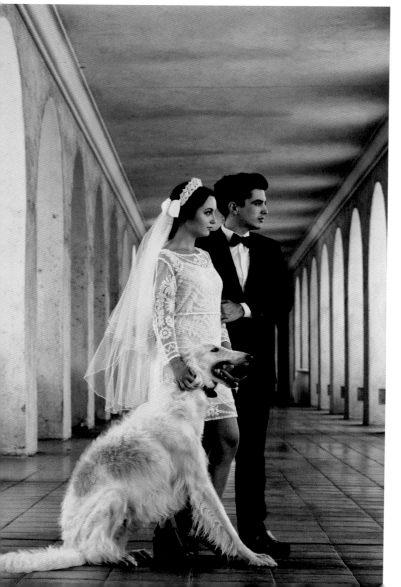

the right position and then start talking to the dog so it wouldn't be distracted. He was so obedient that I got the shot in one take!

As I was flying home, I started to think about what a great photo session it had been. I realized that it would make a nice promotional piece to send to couples who had just gotten married—even weeks or months after the honeymoon!

At these sessions, we can tie in a few images of the bride with the dog, the groom with his best friend, and finally the dog in the couple's new home. We might even toss in a framed 5x7-inch print so they will never forget us. You can be sure they will brag about that photo—and brag about *you*. That means money in the bank!

6. THE RINGS

One of the symbols of a wedding is the ring exchange; it seals the love between a couple. There are many different ways in which we choose to photograph the rings, so I would like to share my favorites. I call this my money shot, and that's because they buy this image every time.

STEP ONE

I first start by having her drop her shoulders into her husband. I want them very close together.

STEP TWO

I want her to hold her flowers so I have a nice background to the image.

STEP THREE

I make sure their heads are close and his far arm is snug around her waist, pulling her close.

STEP FOUR

Now the hard part: I apply pressure to her knuckle so I can softly bend her

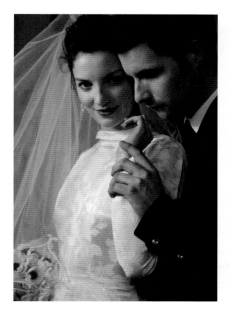

hand in a delicate and feminine position. Once I have that, I quickly add his hand.

FINISHING TOUCHES

Once his hand is in place, I try to make sure his shirt sleeve is showing, so I have a nice separation between his tuxedo and the shadow area of his hand.

VARIATIONS

I shoot this with a few expressions. Then, I photograph the hands and the rings. That makes a great panorama page in the album. At the reception, I usually borrow the rings while the couple is having dinner and set up a few additional ring shots.

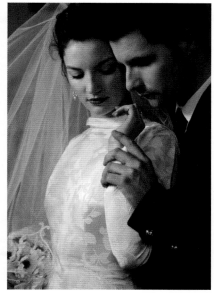

7. ROMANTIC POSING

In the first image (*below*), I wanted to illustrate how leaving negative space gives the image more impact—more drama. I decided to make the man more of a prop in the image and placed him on the shadow side, where he is barely visible.

In the second image (*facing page, top left*), I combined a two-thirds pose for the woman with a profile pose for the man. This is always a strong look for a romantic portrait of a couple. Closing their eyes adds even more power to the image. Make sure the man is slightly higher than the woman; sometimes I'll use a stool to adjust their relative heights.

The third image (*facing page, top right*) shows a pose that is one of my favorites—however, I always have to physically show the man how to achieve it. He needs to kick up his heel on the tree, lean back, and put his hand in his pocket. Then I have her lean into him. Start with a double profile shot, then have them touch foreheads, and then kiss. Make sure you get three-quarter shots, too. (*Tip:* Get down low when you shoot this; it makes them taller and adds lots of impact!)

In the last image (*facing page, bottom*) clutching the hands gives a sense of warmth and excitement.

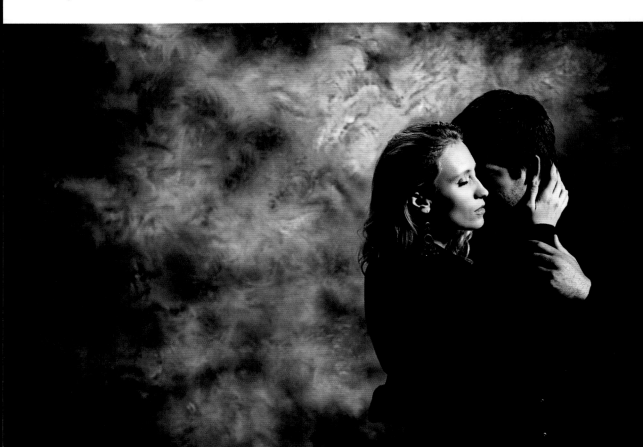

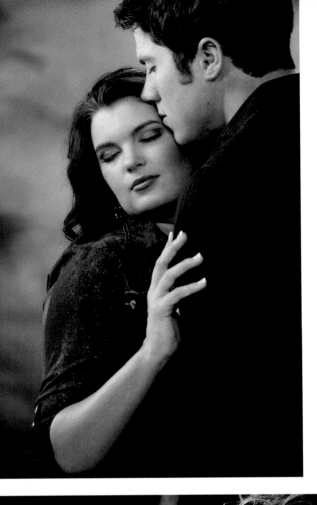
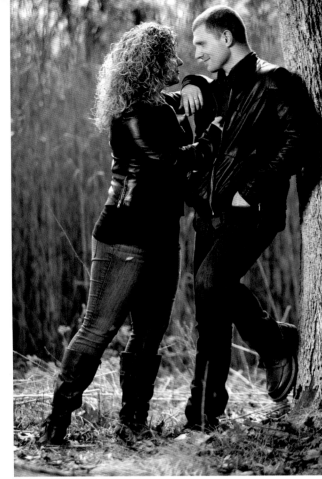
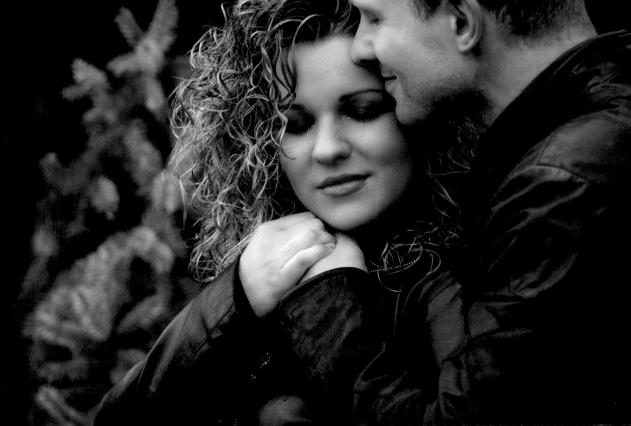

8. MASTER DIRECT SUN

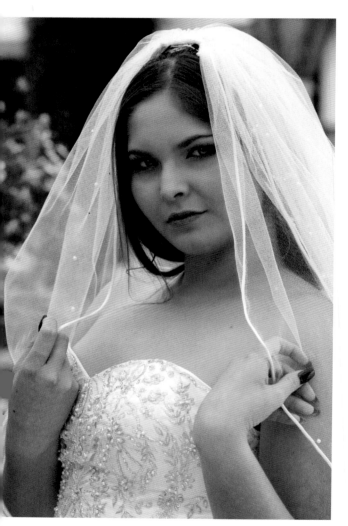

Even though the sun itself is huge, it's also 93 million miles away from us. As a result, it functions as a very tiny light source relative to us here on earth. So how can we control the harsh light and shadow this tiny light source causes?

CONTROL THE TIME OF DAY

The ideal solution would be to dictate the time of day we need to shoot with our client (times near dusk or dawn when the sunlight is indirect), but that's not always going to happen.

CONTROL THE DIRECTION OF THE LIGHT

When you have to shoot in direct sunlight, start by positioning the subject as best as you can relative to the direction of the sunlight. If you're trying to shoot at noon, this is going to be challenging—but even at 10 or 11AM, it can be done. Look at the sunlight on your subject's face and make sure you are starting off with some kind of nice highlight and shadow pattern.

CONTROL THE LIGHT YOU HAVE

Once the basic pattern of highlights and shadows is looking good, the next objective is to control the dynamic range of the light exposing the subject. To do this, I like to add a scrim (a sheet of translucent material) between the subject and the sun.

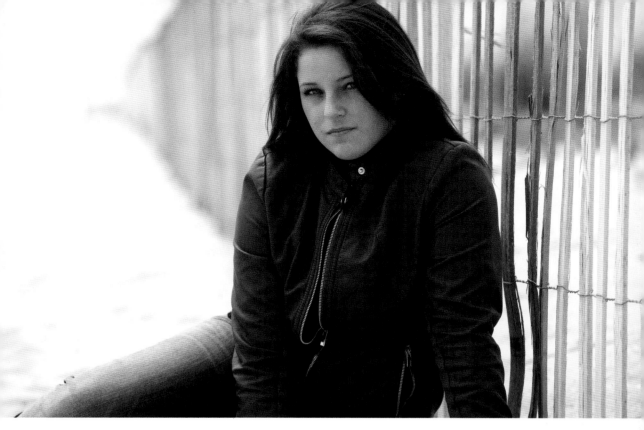

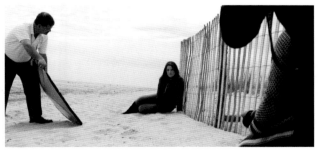

This softens the light for a more flattering look. Then, I meter under the chin to get the exposure level.

Another way to control the ratio between the highlights and the shadows is to use a reflector (silver, white, or gold, depending on the look you want) to bounce sunlight back onto the shadow side of the subject. Adding flash fill would be another option to open up the shadow areas and control the overall contrast.

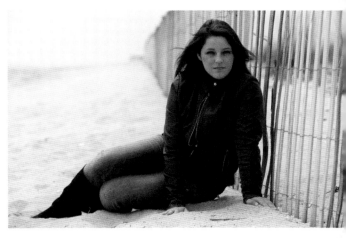

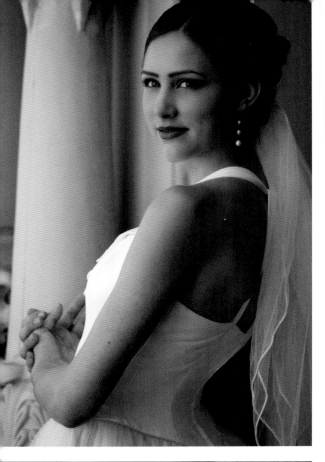

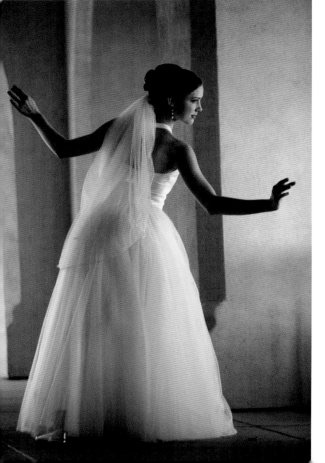

9. AMBIENT EXPOSURE

I know there are lots of photographers out there who love to shoot with ambient light. I like ambient light, too—but there is more to tell! You have to say to yourself, first, what do I want to do with this available or ambient light? How can I make this person look great with it?

METERING

Well, it was inevitable that I would bring up the "m" word sooner or later. Yes, it's time for my trusty light meter! I know that a lot of photographers are not hooked on using a meter or do not want to purchase one—and that's fine. I know that lots of you just want to look at the subject from behind the camera—and that's fine, too.

However (and I hate to be the one to break it to you), the in-camera meter is not accurate. It only gives you an overall exposure for the whole scene. Some people think turning on the histogram is the solution, but this is also not the best way to go. Why? If you are specifically trying to create beautiful lighting on the subject's face, neither this in-camera meter nor the histogram is giving you the whole story.

WHY IT MATTERS FOR DIGITAL

Digital is more precise than film. For the highlight side of the exposure, you can only be

off by .3 stops and hold the detail. So if your meter says the ambient light on the face is f/5.6, anything at f/5.6.4 (or higher) will not have detail in the whites. That's a big problem if your subject is wearing a wedding dress! The inverse is also true; there's not a lot of wiggle room before the groom's black tuxedo starts to lose detail. Metering is critical.

CONTROL THE EXPOSURE

I want to know exactly what my ambient light level is *before* I shoot. That lets me make the best decisions about subject placement and any additional light modification I might need.

From there, I can adjust my shutter speed and aperture to help me control how my camera records the light. If I have an overcast day, I'll probably need to use a longer shutter speed; if I want that beautiful blue sky to be darker, I can increase the shutter speed. All of these decisions, however, start with metering and getting great light on the subject.

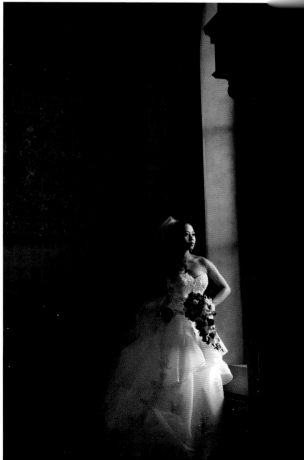

Ambient Light Portraits

Directional lighting is critical to great ambient light images. Windows, porches, and even umbrellas block the overhead light and create a very flattering look.

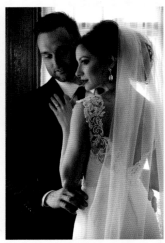

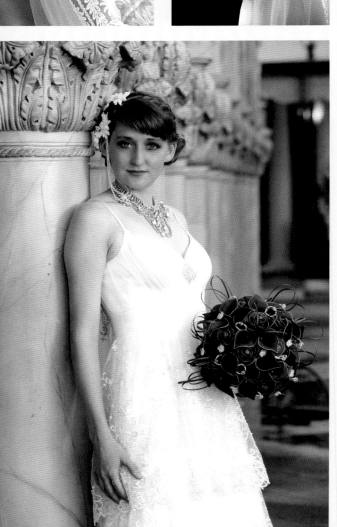

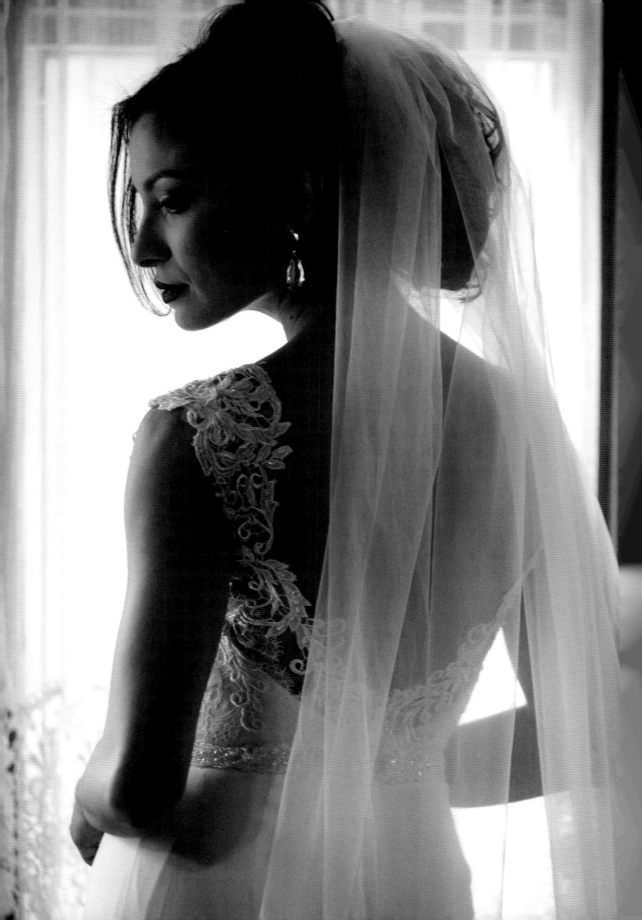

10. ADD A REFLECTOR

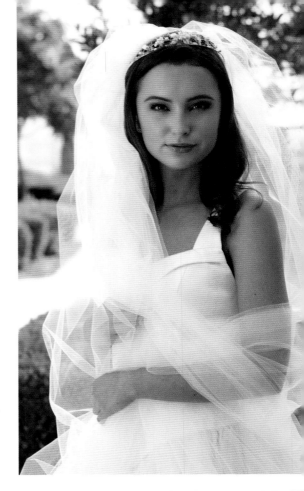

LIGHTING OVERVIEW

These images were shot using the late afternoon sun. There was a building to camera right that blocked the sun from spilling into my camera's lens and causing lens flare. After metering, all I had to do was position my silver reflector so I could bounce sunlight back onto the subjects' faces, as seen in the diagram below. I use this method quite a bit when working with ambient light

REFLECTOR FINISHES

There are different kinds of silver reflectors, but I prefer the soft silver finish. The hard silver reflector can cause deep pockets of specular highlights that are difficult to retouch from the face.

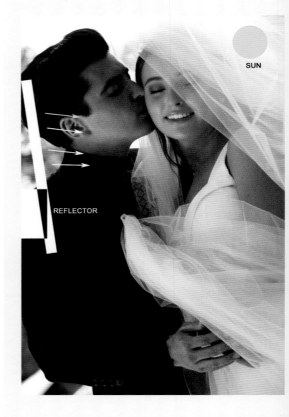

SUN

REFLECTOR

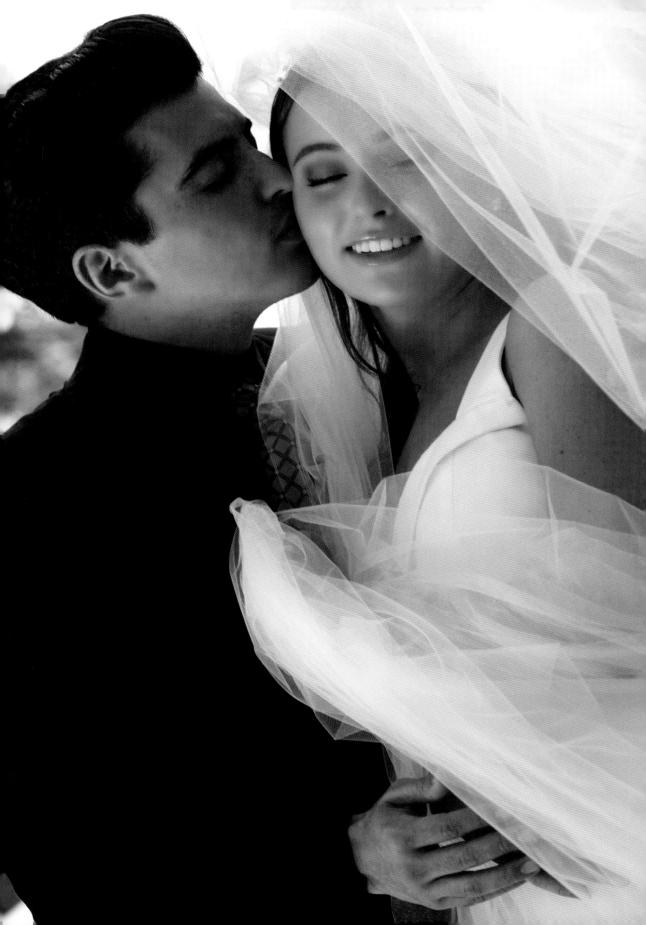

11. OVEREXPOSING

CONTRIBUTORS: Rick Ferro and Deborah Lynn Ferro

With digital, you are usually concerned about preventing the highlights from blowing out—but with this overexposure technique for portraiture, you want to do just that. By overexposing two stops, you can create porcelain skin and incredible fashion images.

THE BASIC SETUP

The background can be simple white paper or a white wall. We used a "tough white" canvas for the sessions seen here. A distance of 5 feet from the model to the background is adequate and eliminates the need for more lights.

For the main light, we use a 36x48-inch Westcott softbox and strobe. This is turned to a horizontal position and placed as close as possible to the subject. Look closely and make sure you can see the softbox's reflection in her eyes. (Seat her on a posing stool so it's easy to get close and move the softbox until it's exactly where you want it.) Our hair light is a 12x36-inch Westcott strip light. We use louvers to direct the light exactly where we want it on her hair. For fill, we use a Westcott Tri-Flector under the subject's chin. This softens the shadows and places a secondary specular highlight in the eyes.

LIGHTING AND EXPOSURE

Is important to structure the exposure settings so that it all comes together. I set the hair light at f/5.6 and place it directly over the subject's head, close to the ceiling. I want the main light to read f/16 on the subject. Be sure the Wescott Tri-Flector is in place before you take the final reading. The Tri-Flector will add about half a stop of light, so don't forget to either lower the power of the main light, or move it back a little, and then meter again. To overexpose the images by two stops, my camera will be set to f/8 and ¹⁄₆₀ second at ISO 100.

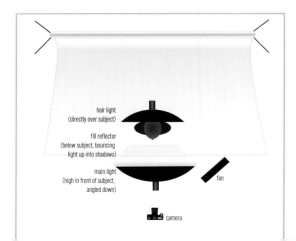

hair light
(directly over subject)

fill reflector
(below subject, bouncing
light up into shadows)

main light
(high in front of subject,
angled down)

fan

camera

VISUALIZATION

With overexposing, it's creitical to envision the final image before you snap the camera shutter. We like to leave lots of negative space for a postcard look. Direct your lens so her face is centered; otherwise, the camera will zoom in and out and never find the focus. Then, recompose the face off-center to shoot.

Adding a large fan and a some upbeat music will make this experience more memorable and easier to photograph. This is one time when you'll want to show her what you're doing on the LCD screen on the back of the camera. It creates excitement when she views some of the images.

THE FINAL TOUCH

You will see that very little retouching needs to be done in an overexposed image. This is because most of the imperfections and blemishes have been blown out, leaving a beautiful porcelain complexion. If any lingering dark shadows under the eyes or on the face need to be removed, that can be done using the Healing Brush or Patch tool.

To bring back any detail, use the Multiply blending mode in the Layers palette. You can also use the Burn tool for selective darkening of the eyebrows, eyelashes, and eyeshadow. The lips can also be burned in, if so desired—but sometimes it is more dramatic to leave them overexposed. For the eyes, use the Burn tool to darken the pupil and burn a rim around the iris of the eye. Use the Dodge tool to brighten the catchlight(s).

An Award-Winning Image
by Rick Ferro

I took this image while teaching the Mars School in New England. The position of her arms creates a gentle diagonal that directs us to her face, which is slightly tilted to left. The pose has a triangular shape created by the position of her arm. Notice that she doesn't press into her face with her fingers; you want a smooth touch. Also, you don't want the hand to be the same size as her face or to take away from its structure. Using the Rule of Thirds, I carefully framed her so that her face was not directly in the middle of the frame. The addition of this negative space compliments this image. The S curve is also well executed; you can follow the curve from the bottom of her arm all the way up to her eyes. The color harmony was accentuated by painting in red on her lips and her bracelet in Photoshop. This image received a Fuji Masterpiece Award.

12. EYELIGHTER GLAMOUR

For these images, I used a glamour lighting setup. Take a look at the setup shot *(top right)* to see how I did it. The only big difference between the scene in this shot and the images featured here is that I switched to a high-key backdrop.

BASIC LIGHTING

Above the model, just to her left, there was a hair light aimed at the back of her head. The main light was aimed toward her face from close to camera-left. It was

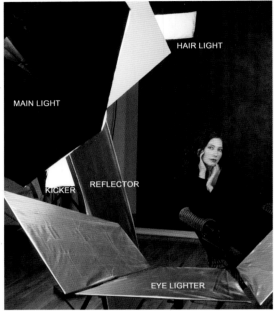

raised so that it created a small shadow under her nose. The shape of this shadow is indicative of a lighting pattern called "butterfly lighting."

I also added a kicker light, which was positioned right behind the silver reflector seen to camera left.

ADD THE EYELIGHTER

The large tri-fold reflector that is positioned low in front of the model is called the Eyelighter. Its main objective is to create a secondary, crescent-shaped catchlight in the lower part of the eyes. This adds a glamorous edge by emphasizing the color and beauty of the eyes.

13. BLOCKING

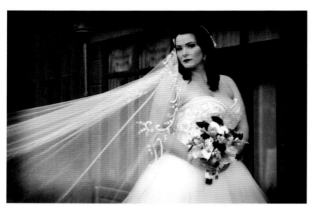

Blocking is a term we use a lot in photography. In the wedding business, I think blocking (using elements in the foreground between the subject[s] and the camera) is a simple way we can enhance our images. These images are all from the same wedding with an absolutely beautiful bride and groom. They were a very attractive couple and I wanted to do whatever I could to enhance their images.

VEIL AND FLOWERS

For the top left image, I extended her veil to fill the negative space behind her. I also enhanced the image by bringing in the flowers, held gently at her waist

FOLIAGE

In the bottom left image, I wanted a strong portrait base, so I had her stand just behind a bush that would provide a soft frame and also slightly obscure her in a flattering way. The flowers were then brought into the lower part of the frame.

Then, I moved her husband into the frame and adjusted them both to flattering two-thirds views. I shot looking down to give the composition more power, tying it all together—her husband, the soft foreground foliage, the flowers, and their romantic, subdued expressions.

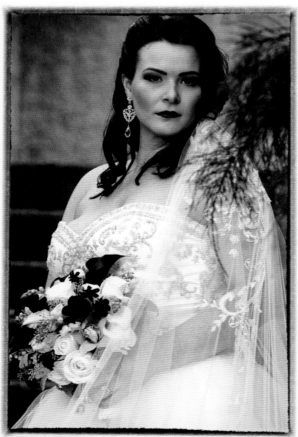

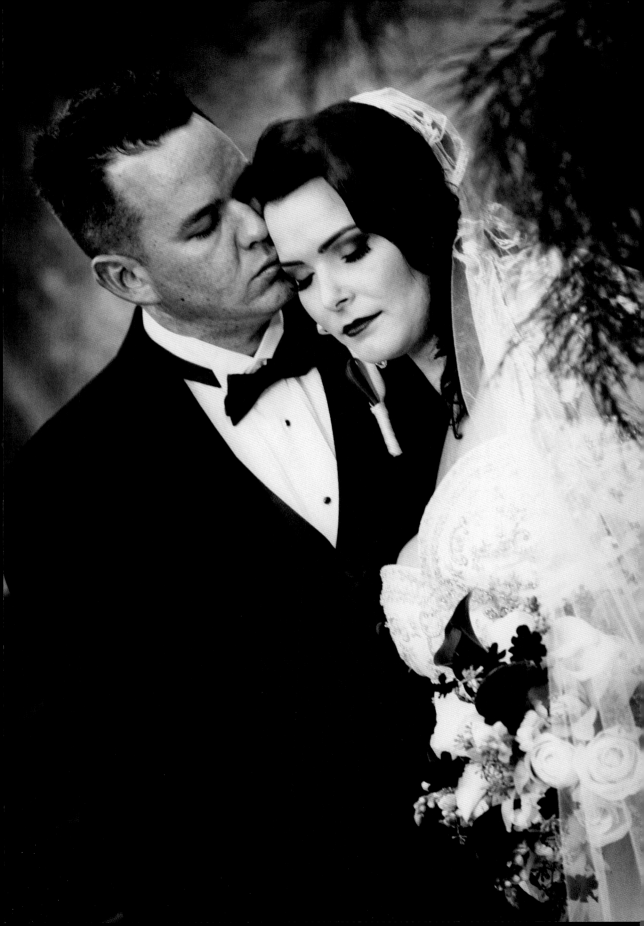

14. SUCCESS IN WEDDING PHOTOGRAPHY

Building a successful wedding photography business requires a substantial investment in equipment, energy, and time. There are many ways to learn the needed skills and further develop those you already have. Even if you graduate with a photography degree, you'll find that your training in the real world continues every day. Photography is an art you will never stop learning, and the effort you put into mastering the professional techniques of the craft will pay off exponentially.

PROFESSIONAL ORGANIZATIONS

Join your local guild first, then invest in joining the national groups (like PPA and WPPI) and attending their conventions. They always have something going on and it will always be a new and fresh idea about photography. Professional organizations can be a great help as you get your career under way and continue to grow creatively and professionally. Some groups have monthly publications loaded with helpful ideas and information.

INVEST IN KNOWLEDGE

There are countless instructional books and educational DVDs on the market—and now the Internet has really contributed to learning. Taking classes with professionals whose work you admire is a sure way of learning valuable skills through hands-on training. I would recommend you invest in as many learning resources as you can afford.

ASSIST EXPERIENCED PHOTOGRAPHERS

Another great way to improve your skills is by volunteering to work with a master wedding photographer. Better yet, try to assist a number of different master photographers; it's always enlightening to see how other photographers work.

DEVELOP YOUR PORTFOLIO

To sell your skills, you'll need a portfolio of wedding images. If you assist another photographer, he or she may allow you to shoot a few wedding candids that can be included. Or, consider introducing yourself to a local bridal shop and asking

66 Even if you graduate with a photography degree, you'll find that your training in the real world continues every day. 99

to borrow a wedding dress in exchange for printed images.

If they consent, find a model and take her out into the field—or, you may be able to secure permission for a mid-week shoot in a church to add a little variety to your samples. Then, return to the bridal shop with a few great prints as trade and leave them your card. This is a great way to get started!

As you increase your skills and business, you may wish to compile several portfolios to match the varying budgets of your wedding clientele.

SHOWCASE PROFESSIONAL PRODUCTS
If you decide to open your own studio, you should also plan to invest in professional framing and a few canvas prints to display. This will tell your clients that you are a professional and that they will be happy with the quality of your work.

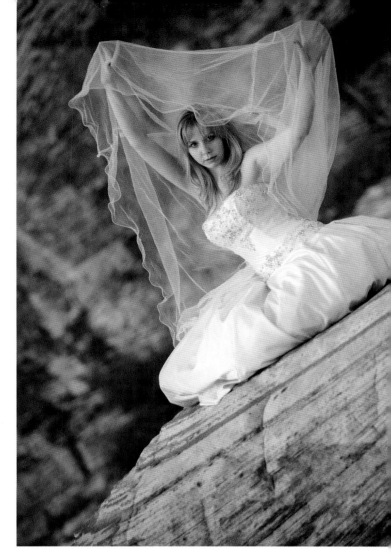

GET SMART ABOUT PRICING AND PACKAGES
You must think through your pricing and establish a serious game plan so you won't need to hesitate when clients ask for a price.

For new photographers, the most important thing to keep in mind is costs. Make sure to include *everything*— processing, batteries, an assistant, albums, enlargements, insurance, square footage on the space you own or rent, travel expenses, your basic wage (plan on six to eight hours for a wedding), and anything else you pay for to provide wedding coverage. You can't establish a profitable pricing strategy until you fully understand your costs.

It's also important to determine what kinds of packages will work for you. There are infinite variations. And remember: whatever packages you offer, clients are ultimately paying for the *quality* not the *quantity* of your work. You need a lot of great images to fill an album, but not at the cost of quality.

15. ASSISTANTS AND SECOND SHOOTERS

ASSISTANTS

An important duty of an assistant is to make sure that all of the equipment is accounted for throughout the day. An assistant should also be trained to help with lighting, metering, and the styling of the bride's dress and veil (see below). I have also made it a practice to train my assistants to become wedding photographers themselves someday.

As you work with an assistant, you should develop something of a secret language of keywords and hand signals that will allow you to communicate efficiently with each other without disturbing your

Styling the Veil and Dress

The veil and dress are important and symbolic parts of the wedding day. You should take care to treat them gently and style them with care for every image. The basic principle for styling the gown is to make sure it falls smoothly and naturally without hitting any obstructions. You should also try to arrange it so it falls as straight as possible. In sections 1 and 13, we already looked at a few options for using the veil as a prop. If it's not going to be intentionally used in such a function, it should be styled to fall smoothly and naturally.

> **I believe that great photojournalistic shooters possess a God-given instinct for great moments before they happen.**

clients. For instance, I might suspect that a light is malfunctioning. In that case, I will give my assistant a particular expression. If he or she responds "ambient light," this lets me know that the flash did not fire. Rather than derailing the shoot, I will simply reposition the subject(s) while my assistant works on fixing the light.

SECOND SHOOTERS

I have a great admiration for second shooters. In fact, now that I look back in my life as a traditional wedding photographer, I actually wish I would have had more opportunities to work as a second shooter—or as they sometimes say now a "Photo J" (photojournalistic) shooter.

Don't get me wrong, being the lead photographer is wonderful and rewarding, but second shooters get to focus more on the emotions of the day—moments that the lead shooter sometimes misses while

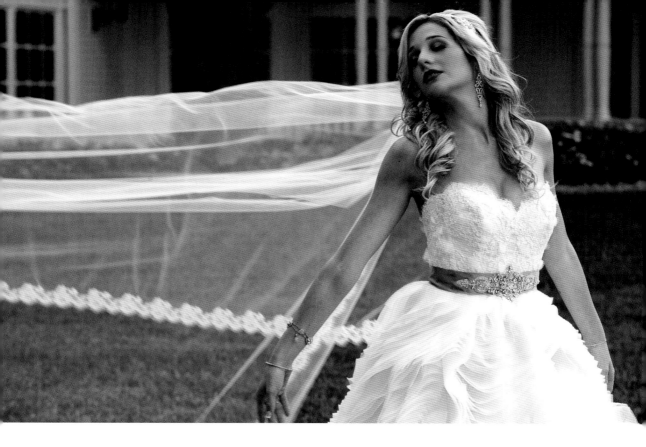

shooting the more formal images. Being able to quietly document Mom's tears or Grandpa holding hands with Grandma while in a wheelchair . . . it's breathtaking.

These behind-the-scenes emotions are compelling and capturing them is a real skill. I believe that great photojournalistic shooters possess a God-given ability to sense what is happening behind them and an instinct for great moments before they happen.

A great wedding photojournalist knows how to capture the essence of the moment at it really exists. For the pure photojournalist, there are no setups; you have to look and wait for the perfect moment or emotion to present itself. The effort can be exhausting—and if you don't have emo-

tion within your mind and body, you will not (in my opinion) be successful. You are photographing a couple's most important day and they are relying on your emotions and expertise to provide them with a lifetime of memories.

Here are some final tips for second shooters. First, I always recommend you stay as far away from the main shooter as possible. Also, I recommend that you shoot wide open as much as possible—and the longer the lens, the better. Finally, don't be nervous when using higher ISOs; on today's advanced cameras, they are producing amazing quality with minimal noise.

16. THE BRIDE GETTING READY

The first images of the day are usually photojournalistic documentation by the second shooter. These images of the bridal details and her process of getting ready will be some of the most important keepsakes from the wedding day.

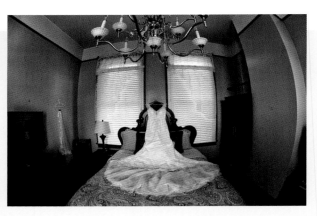

WHAT TO SHOOT

The bridal preparation images should include (at a minimum):

- The bride's dress, front and back.
- Her shoes, jewelry, garter, love letter, gloves, etc.—any important

Don't Settle for "Nice"

This is a time to be creative, push yourself, and give the client more. Try switching up your lenses, adding bounce flash, and working with selective focus *(below)*. Also, shoot everything in color. You can always change it to black & white or sepia later.

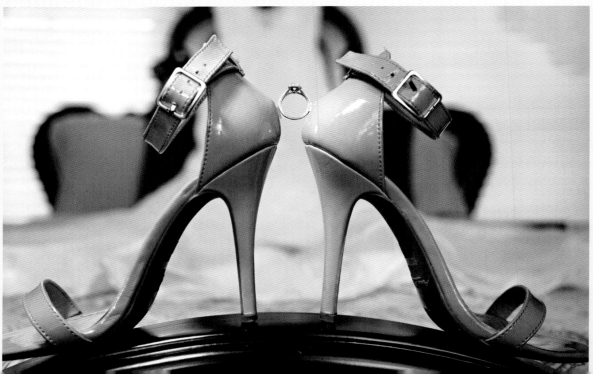

mementos from the day or elements of her attire.

- The bride receiving assistance from her attendants and/or mom.
- Mom helping zip up the back of the dress.
- Her flowers, other accessories, etc.
- The bride looking out the window, shot with ambient light if possible.
- The bride hugging her parents. This will usually happen naturally, so watch and be ready.
- Tears of happiness.

TIMING AND DISTANCE

Not every woman wants images taken before her makeup is applied, so check before you start shooting (better yet, include this question in your pre-wedding interview). Also, try not to be obtrusive when photographing the bride enjoying her special day. I tend to shoot with a Canon 70–200mm f/2.8 lens that always does the trick. I can stay 10 to 15 feet away and still get nice closeups.

SHOOT WIDE OPEN

Shoot wide open as much as possible. Shoes are extremely important to many brides—as is the dress. For the large image on the facing page, I set up the shot to spotlight the shoes but incorporated the dress in the background. The shallow depth of field really sets the tone for this shot. The further you place the shoes away from the dress, combined with a wide aperture setting, the stronger the image will be.

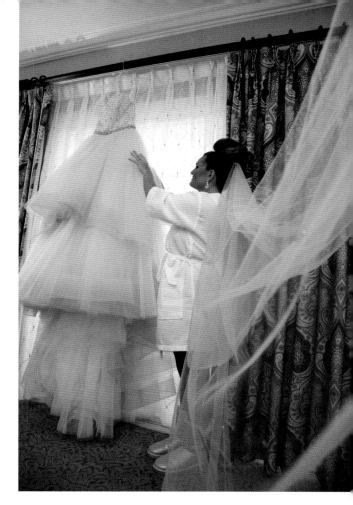

BOUNCE FLASH

I prefer window light, but sometimes I do need to add flash to properly balance the exposure. Typically, I bounce this to soften and spread the light so it never looks harsh. In the image above, I had nice lighting coming from behind the bride but I needed to illuminate her face so I added additional light by bouncing light off the ceiling to compensate for the background. (And remember: if you are bouncing off a yellow wall, your images will be affected with a yellow cast. Be sure to use a custom white balance to avoid a lot of Photoshop work later.)

17. IN THE CHURCH

THE CHURCH AND CEREMONY

Unless you have photographed the venue before, I strongly recommend that you get to church as early as possible and really get a feel for the best angles.

I use at least five lenses when doing a ceremony. I'm positioned down in front of the altar, with a 50mm lens, to photograph the bride as she comes down the aisle. Then, I will go back about fifteen pews and put on my 24–105mm lens and shoot wide verticals and horizontals. Next, while I'm still near the front of the church, I put on my 15mm and shoot super wide vertical and horizontal views. That's already three lenses! Next, I go all the way to the back of the church and use a 70–200mm and a 300mm lens to shoot vertical and horizontal images. If there is a balcony, I repeat everything from that perspective.

You should also be prepared to shoot a variety of detail images of the altar after the ceremony. Shoot the flower arrangement, the candles, the stained glass windows, and any other important features. If you have access to the couple's wedding invitation, try combining that in a photo with the church candles.

With repeated shooting at a site, you have a wonderful opportunity to get really comfortable with the unique lighting characteristics and special features of the setting. This allows you to build a repertoire of shots that you know will work perfectly every time.

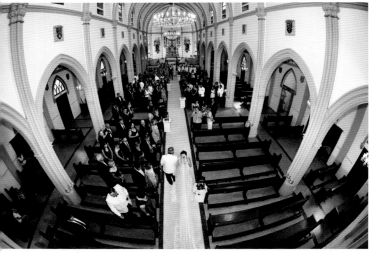

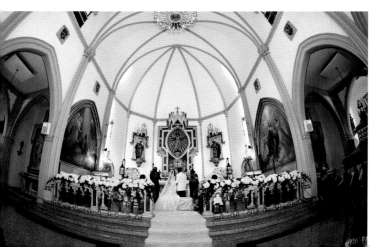

❝ You should be also prepared to shoot a variety of detail images of the altar after the ceremony.❞

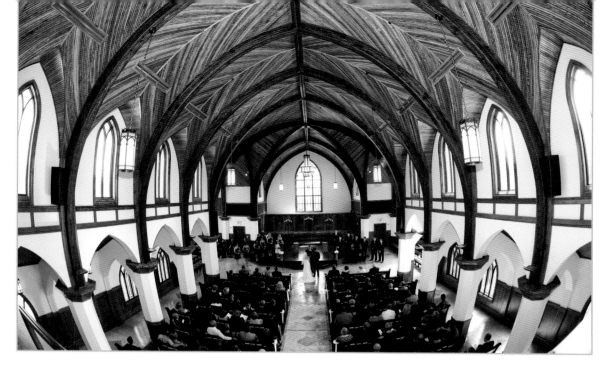

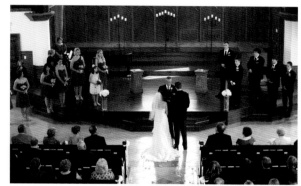

CEREMONY VARIATIONS

Although the major elements tend to be the same, you should talk with your clients about the characteristics of their ceremony.

For example, when shooting a Jewish wedding, I have found that I have very little time to shoot. I may only get an image or two during the ceremony and a quick return trip back to the altar. However, the bride and groom usually see each other before the ceremony, so I can get a lot of their photography done at this time. I can

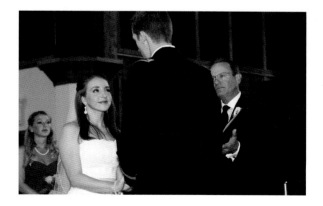

usually also cover the family groupings before the couple's ceremony begins.

If the ceremony includes a communion, I back away and don't photograph it. This is an especially sacred ceremony and I don't need to be clicking away or making any sounds as I move around.

BE UNOBTRUSIVE

My most important advice for photographing the ceremony is to be unobtrusive. Yes, the couple wants great photos—but not at the expense of their ceremony. This means that I never shoot with a flash, even if the church allows it. I also try not to walk around too much. I take a few shots from the noted positions and then keep my distance to allow the couple and their guests to experience the event without distractions. My couples know we will return to the altar after the ceremony for some wonderful images when I can set them up carefully and light them properly.

RETURN TO THE ALTAR

Don't get overly stressed out about trying to fully document every little aspect of the ceremony as it happens. Instead, once the ceremony ends, have the couple and the minister return and re-stage some of the key shots, like the ring exchange, kneeling at the altar, or anything that you didn't feel you should take at time! This will allow you to employ a full range of camera positions and lighting options so you can get each shot just right

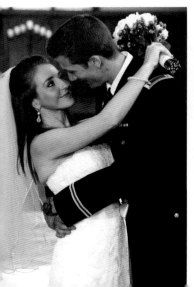

POSING FORMALS

Formals are the part of the wedding photography for which you need to reserve the most time. In these images, you need to keep an particularly careful eye on the design. Examine the lines of your subject and the lines of the background. I like fluid lines and tend to look for S-curves. I also like images with perspective, so I am very fond of including architecture in my wedding formals.

I urge you to take the time you need to pay close attention to the details. Little

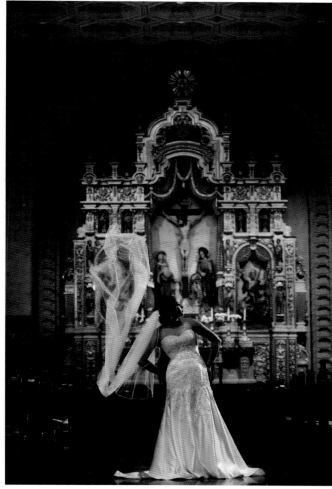

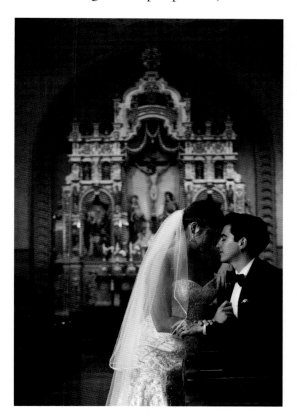

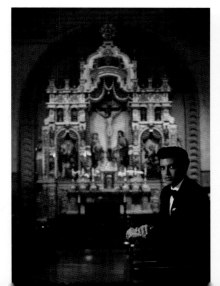

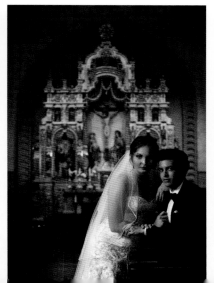

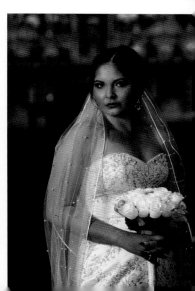

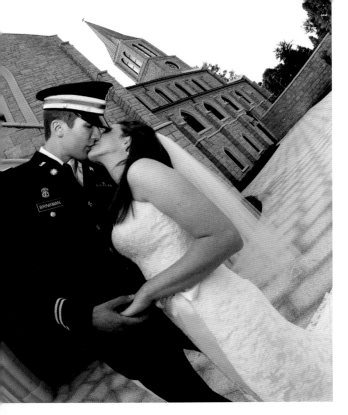

things like a not-so-perfect veil, a crooked tie, or the stems showing on the bouquet can ruin an otherwise beautiful portrait. It may not seem like much, but the details can make or break an image. Don't rely on

Timing

Often, things are running late and you haven't shot a thing by the time the "planned" time-frame. This is a problem all wedding photographers encounter. When that happens, I ask the groom to explain to the church coordinator that we need more time. We can't be held accountable for our clients' tardiness. One thing that's great about our digital cameras is that the exact time we each photo is recorded automatically. If you ever get a phone call about a "missed" shot, you can always show them your time sync.

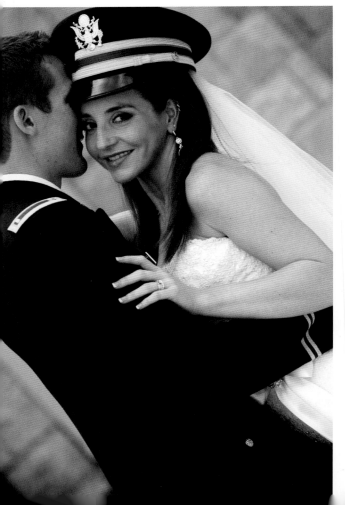

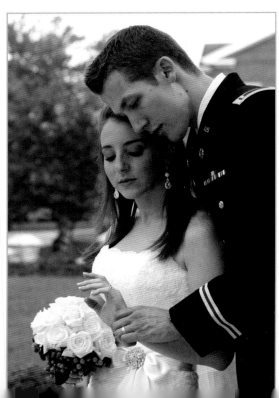

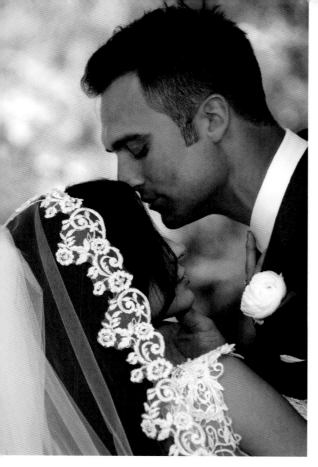
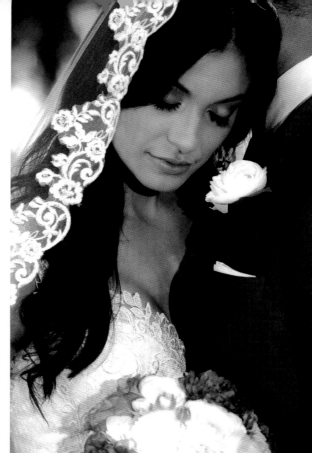

Photoshop. (Be sure to check the hands, too. The poses will feel more polished when the hands look relaxed and elegant.)

I like some "dance" in my poses—a sense of swing or movement that makes the photograph feel natural and vivid. After all, you are looking for elegance in your images. Why would you settle for a pose that just makes your subjects look stiff?

Be confident when instructing couples on poses you are looking for. Your con-

66 I like some 'dance' in my poses – a sense of movement that makes the photograph feel natural and vivid. **99**

fidence will assure them that they are in good hands and will encourage them to put their trust in you.

QUIET TIME

What is quiet time? It's a time you set aside to do all the creative images you talked about with your client. Normally, it's right after the ceremony. However, if the couple wants to see each other before the ceremony, we'll do the images then. In section 21, I'll lay out the flow posing method I use for these images. I shoot these images from a tripod so I can pose them more quickly without having to set my camera down or recompose for each shot.

18. THE WEDDING GROUPS

Group portraits are an important part of the photography for just about every wedding. With these images, solid planning is the key to success. Knowing when and where you'll be taking the shots—and planning the groupings that need to be included—will make the process go much more smoothly.

ENLIST THE MAID OF HONOR

It helps to enlist the assistance of the maid of honor for these pictures. The bride will have a lot of things on her mind—from her own appearance to the comfort of her guests. Part of the maid of honor's job is to help and minimize the bride's stress. As such, before you arrange the area you plan

Formal Finesse

The couple's family will normally be dressed formally, so I scout the church for windows and doorways that I can use to frame them. The lighting in these indoor images was from two flashes. The first is my main light, which is usually to the right (I always try to put it on the women's side of the frame). The second light is mounted on my camera for fill light. I

have the main light on manual at $\frac{1}{4}$ power and the fill on manual at $\frac{1}{8}$ power. The most important tip I can share is to get down low so you won't have reflections on the glass; it's hard to get them out later. Once I have photographed a full-length shot then I move in closer for a three-quarter-length pose. The 24–105mm lens can do it all.

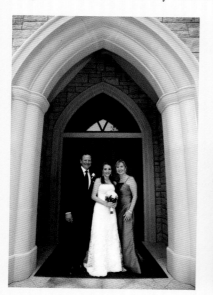

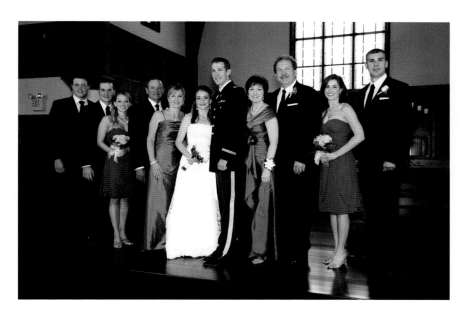

> 66 Once the couple is positioned, I start to add the bride's parents, siblings, and grandparents. 99

to use for group photos, ask the maid of honor to assist you with organizing everyone and styling the bride's gown. The maid of honor's help will be an excellent resource and help to reduce demands on the bride.

POSING GROUPS

Before diving into posing groups, it's good to have a plan of attack. You'll be dealing with a large number of people in a great variety of groupings, so moving them in and out of the scene efficiently and with a minimum of confusion will make the shoot much more enjoyable for both you and your subjects.

If you develop (and stick to) a system, you'll be surprised how quickly the shoot moves. Space will dictate how large the group can be and the options you have for posing, so be prepared to finesse the planned groupings to get the best results.

If the church has a stepladder, ask to borrow it (or bring your own). Using a stepladder will help equalize your views of shorter people and taller people.

THE COUPLE WITH THEIR FAMILY

A good place to begin your group photography is with the bride's side of the family. That's where I always start.

Once the couple is positioned, I start to add the bride's parents, siblings, and grandparents. If any of those people have spouses, I add them next. I will keep building progressively until I have everyone with the bride and groom. Finally, since this is the bride's family, I will ask the groom to step out and photograph the bride with her whole family. Then, I subtract people progressively until I have the bride with just her mom and dad. Then, I start the whole process over with the couple and his family. I add his mom and dad, siblings, grandparents, etc. Using this process doesn't take as long as you think and it ensures that you won't miss important family images.

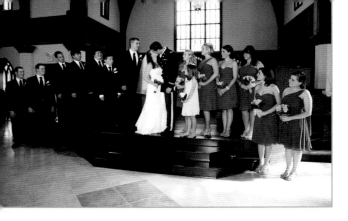

THE WEDDING PARTY

It doesn't matter how many people you have in a wedding party, as long as you have a system. Here's mine, in order:

1. Bride and groom, full length.
2. Bride and groom looking at each other, full length.
3. Switch tighter view and do it all over again—except add a kiss to the mix.

4. Add the groomsmen to the bride's side add the bridesmaids to the groom's side.
5. Have the grooms men look at the bridesmaids and the bridesmaids look at the groomsmen and tell the bride and groom to kiss.

These are my traditional group shots I do every time. It's an easy rhythm to develop and I don't forget anyone!

You'll also want to make sure you create wedding-party portraits featuring all of the bridesmaids with the bride and all the groomsmen with the groom.

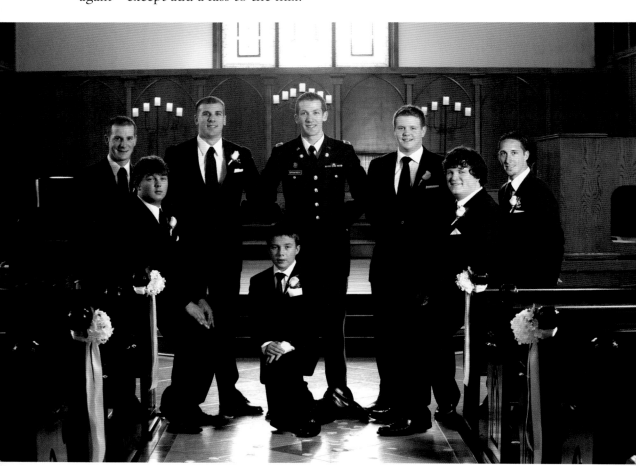

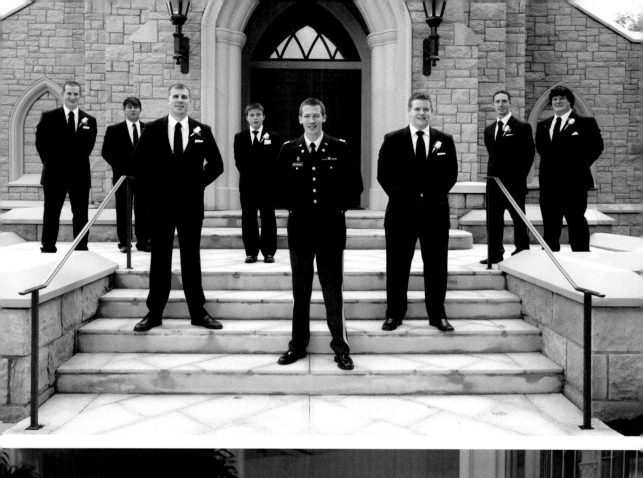
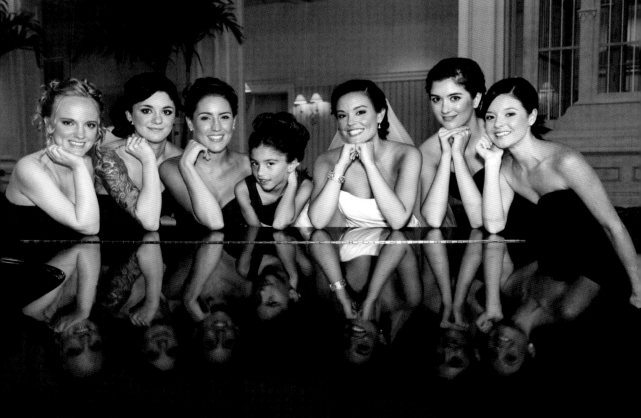

19. THE RECEIVING LINE

In the previous section, I covered the problems we often encounter with timing and couples running late—but let me address, in particular, the dreaded receiving line. We try to stay on time to cover the event and give the couple the creative images we discussed at their consultation—but when the receiving line starts, the whole process comes to a dead stop.

When clients book me, I strongly recommend against including a receiving line in their plans. First, I point out that there may be another ceremony following theirs, so our time for photos at the church may be limited. Also, the couple will have time to greet their guests one-on-one during the reception. I also look directly at the bride and remind her that she'll be standing at the doorway at the church, and if it's summer it will be *hot* (not great for her hair or makeup). Another concern? There's a good chance that someone will get lipstick smudges on the couple's faces, or the bride's dress might be stepped on and smudged or torn.

There are a lot of reasons *not* to host a receiving line. Talking about them might help convince your couple to skip it.

20. THE GETAWAY

EXIT SHOTS

As I'm finishing up the couple's formals inside the church, I know that their guests and families are headed outside to get ready for the big exit. I want it to be special, so I ask the groom to stop halfway out of the church and give her a kiss—and while he's at it, give her a dip! I always encourage this, and you should too. Also, since you know this will be taking place, ask the parents to make sure they stay near the action so they will be in the images.

THE LIMO

Limo shots have really changed for me. I remember when getting the bride and groom to smile inside the limo was the key shot. I do still take that photo of the bride and groom, but I've also stepped up my game with a dramatic image outside the limo (*facing page*). My clients are loving it!

Here's how I do it. First, it's the use of a 15mm lens that gives these shots their impact. I get down on my knees about 3 to 4 feet from the couple and shoot up-

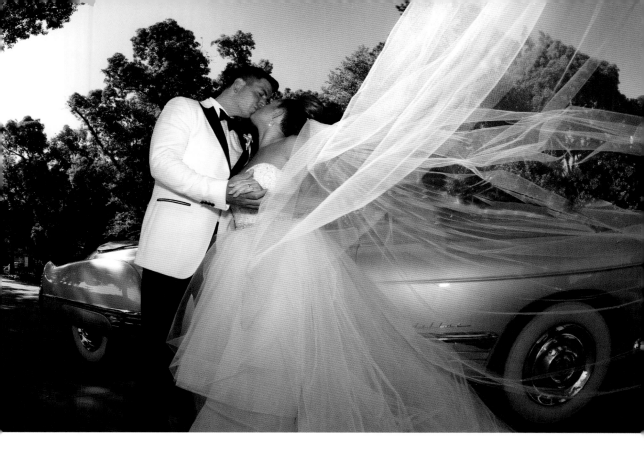

ward for this super-wide view. Then, I have my assistant hold the veil over my lens to create a nice leading line that pulls your eye toward the couple. You want some slack on the veil—just enough so it looks like it's caught in a gentle wind. If you pull the veil too tight it won't have the same effect.

The main light for this shot comes from camera left and is placed behind me. This is because the 15mm lens will see everything—you can't even use a tripod without seeing the legs!

I pose the couple for a double profile so that the light hits both of them. And if they are willing, have them try a deep "dip" pose. This shot is definitely a keeper!

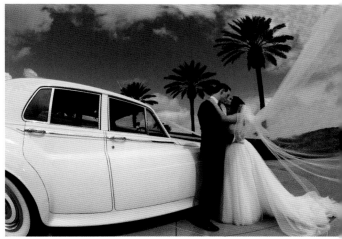

21. PROGRESSIVE POSING

What exactly is progressive posing? It's a simple, efficient system for getting lots of nice photographs in a short amount of time.

THE TIME CRUNCH

Like other wedding photographers, I am always up against the wall when it comes

to time with my couples. In fact, at Disney we only get about twenty minutes to provide our clients with their beautiful, yummy images! For my weddings, I have designed a specific sequence of images (we'll look at this in the next section) that keep the bride and the lighting in one place but take the couple's images to a new level in terms of impact.

MINIMIZE CHANGES, MAXIMIZE IMPACT

I see a lot of photographers set up one nice image and then quickly break it down and re-invent the wheel with a whole new pose and lighting scheme. That's where it will all fall apart. You'll run out of time way before you have all the images you'd like. Instead, stop and think of all the different variations you can produce with

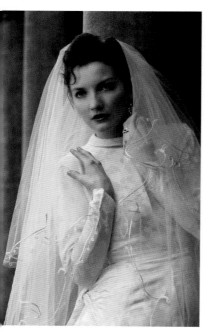
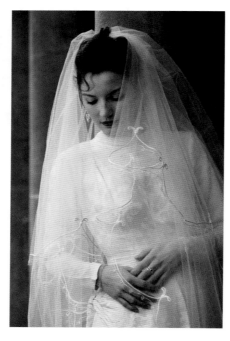
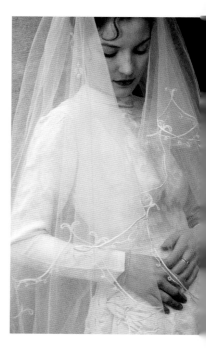

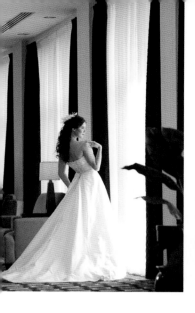
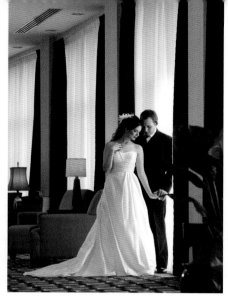
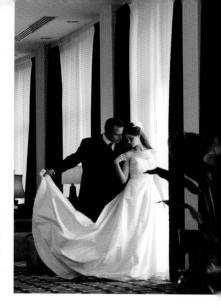

just subtle changes in the subject's pose or your own position. Have her lift or drop her eyes, turn her head, or clasp her hands. Ask the couple to tilt their heads together, or kiss, or have him lift her train.

TRY A DIFFERENT LENS

We all have different lenses, too. So why not push yourself? Set up one beautiful pose and photograph it with three different lenses. See what you come up with!

You might start with a 24–105mm lens for a full-length shot, then switch to a 15mm lens and get down low for a totally different look. Then, finish with a 70–200mm lens and go in for tight shots—maybe over the groom's shoulders into the bride's eyes, or just the bouquet, or even a great shot of just their hands and rings. It's all there. You just have to look for it!

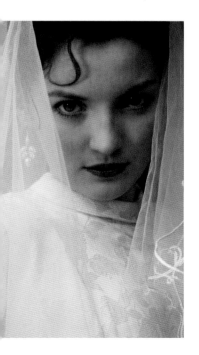
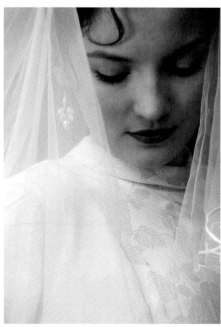
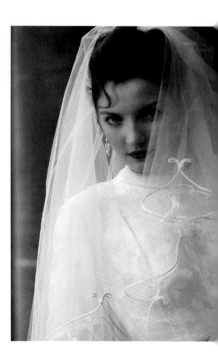

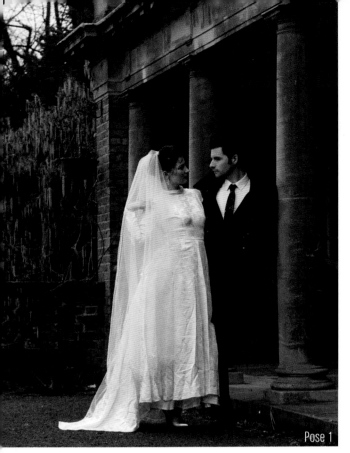

Pose 1

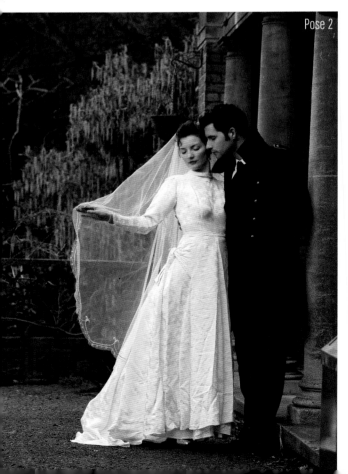

Pose 2

22. SEVEN SIMPLE STEPS

Whenever I do progressive posing, I shoot from a tripod. I'm very quick at posing and it would slow me down to set down my camera and have to re-compose for every shot. With my camera on the tripod, it's also easier to see if the eyes are closed.

Shooting with a 70–200mm lens, I start by posing the couple full-length. Then I work through seven simple variations that progress through small changes. Photographing this entire sequence should not take more than eight minutes. Practice! Practice! Practice!

POSE 1
A double profile, shot full-length.

POSE 2
The bride is in a two-thirds view, the groom in a profile view, shot full-length.

POSE 3
Keep the same pose, move the camera closer, and photograph a horizontal view.

POSE 4
Have them turn to look at each other in a double profile.

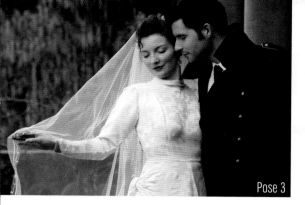

Pose 3

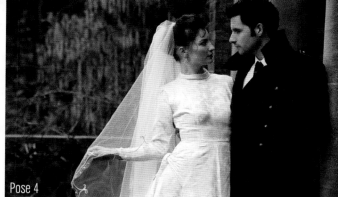

Pose 4

POSE 5

Have them touch foreheads or kiss for another simple variation.

POSE 6

A three-quarter view of the couple. Make sure her arm is bent at the elbow, it's a lot better than leaving it dangling.

POSE 7

Another three-quarter view of the couple, but now let them touch foreheads or kiss.

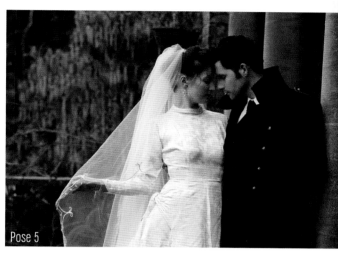

Pose 5

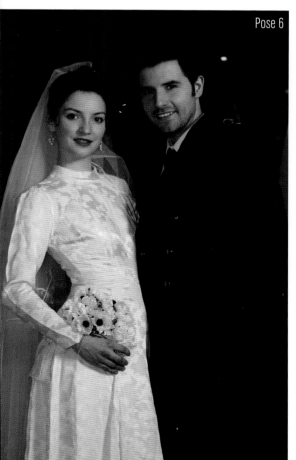

Pose 6

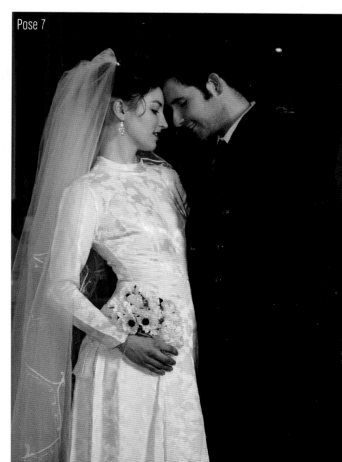

Pose 7

23. ELEGANT HAND POSING

When photographing a bride, what do you do with her hand posing to create a more dramatic look? As you can see in the images below and on the next few pages, you can create a number of very unique bridal portraits simply by moving the subject's hands—often without even changing the lights, camera position, or background

In the photos below, check out the hands in the left photo. Notice that the left hand is a little bit higher than the right. That gives the image a sense of balance. In the photo on the right, I did totally the opposite. The accent hand is on the bride's face, and the other is tucked under her body. Notice that the hand touching the bench is palm-down and the fingers have a nice flow to them.

The next three pages show some additional hand poses you can use to inspire your own work. Try these and experiment with variations that appeal to you and your brides.

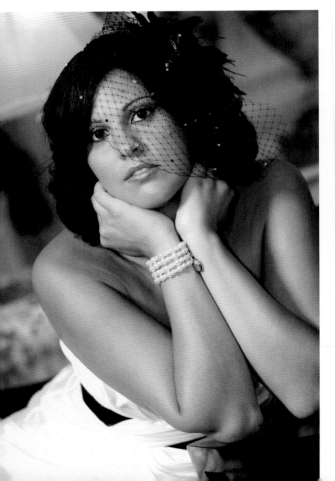
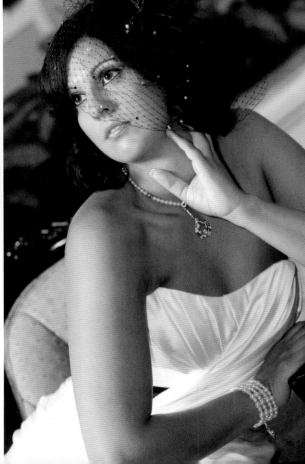

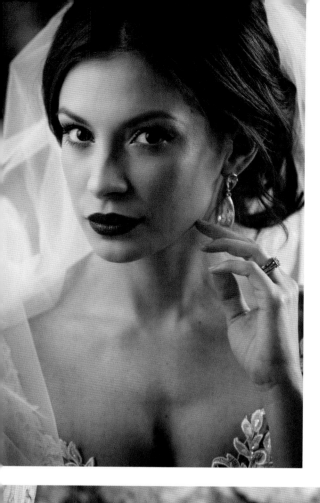
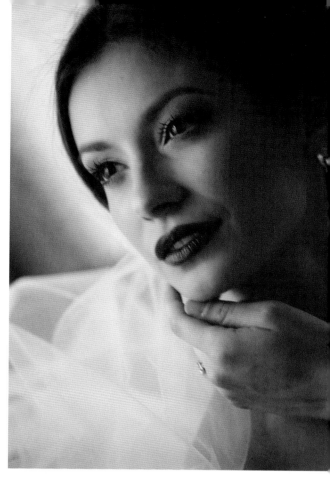
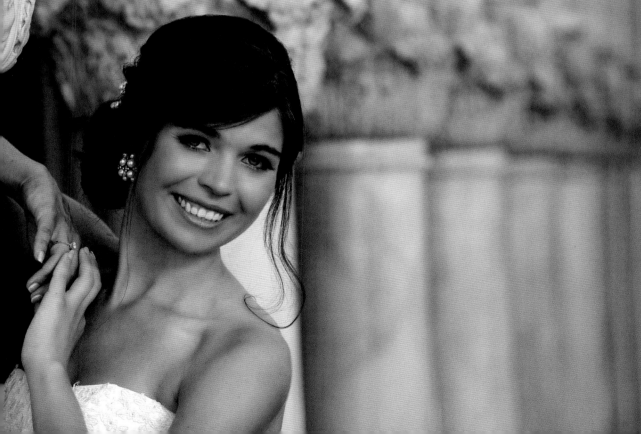

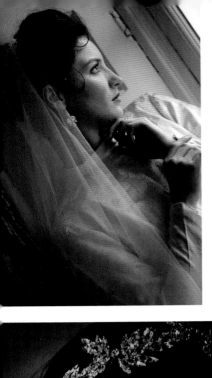
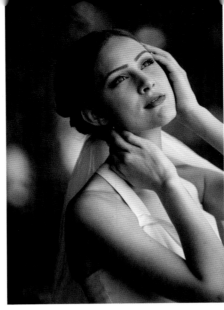
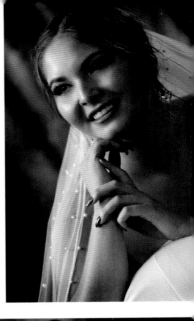
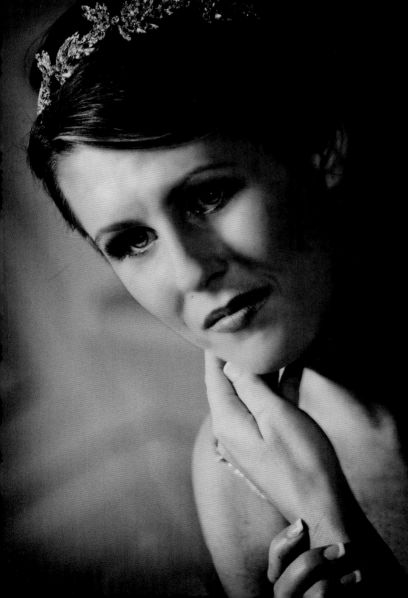

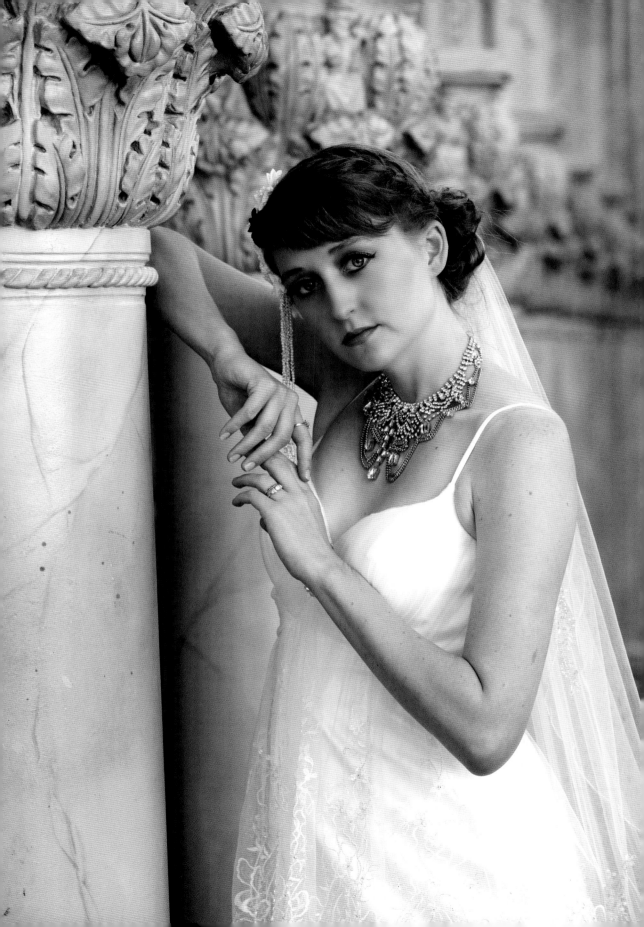

24. TIMELESS PORTRAITS

CONTRIBUTOR: Beth DeMund

My objective in wedding photography is to create the most beautiful and timeless images I can for each and every couple.

This particular photo is one of my all-time favorites because it captures the true beauty of this bride and her calm, sweet disposition in the moments leading up to marrying her very own Prince Charming.

I shot this image on a Nikon D800 with a Nikon 85mm f/1.4G lens using only available light from a window. My exposure was f/1.6 at $1/250$ second and ISO 125.

I had the bride sit on the ground facing a window that was about seven feet away. For a little extra drama, I stood on a chair to create even more of a downward angle to capture the bride's face with only her dress and veil as the background. I used a very shallow depth of field here to draw the viewer's eye right into the bride's face and eyelashes, letting the details of her dress create a soft dreamy background.

I also turned the bride's face to a perfect two-thirds view on the left side of her face so that there is just a sliver of skin showing between her eye and the edge of her face on the left side of the image.

I kept the post-processing to a minimum to ensure the image stayed clean, light, and real. Converting the image black & white was the final touch to make this photo a classic work of art the bride can cherish forever.

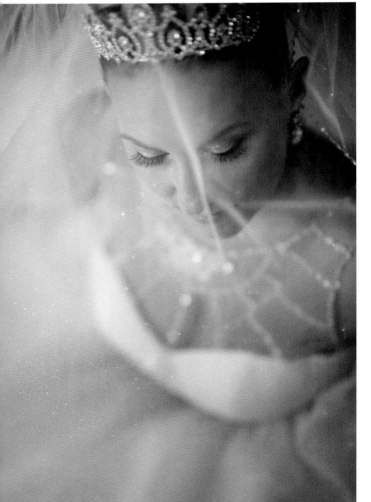

Beth DeMund is a wedding and portrait photographer based in Central Florida. She is proud to be a member of the Disney Fine Art Weddings team.

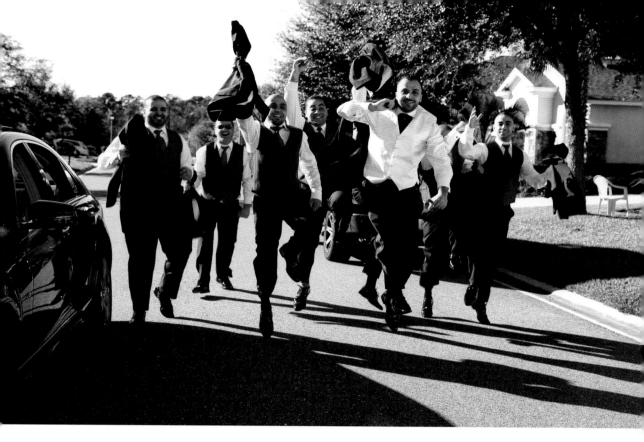

25. HAVING FUN

Sometimes it's easy to get too caught up with following the "rules." Yes, you need to get the traditional images, but there's no reason you can't also get some really fun, unique shots along the way.

BE CREATIVE

When you're shooting an energetic group, have some fun with them and make some images that will be memorable additions to their wedding album. Try to create images that really reflect the character, joy, and fun of the day. Let yourself get caught up in the action! This is where shooting digital is a huge advantage: there's no extra cost involved with experimenting.

Learn Their Names

There are a lot of people involved in a wedding. At a minimum, you should know the names of the bride and groom and perhaps their parents. Knowing the names of the maid of honor and best man can also be very helpful; they can assist in getting people organized.

26. THE GROOM

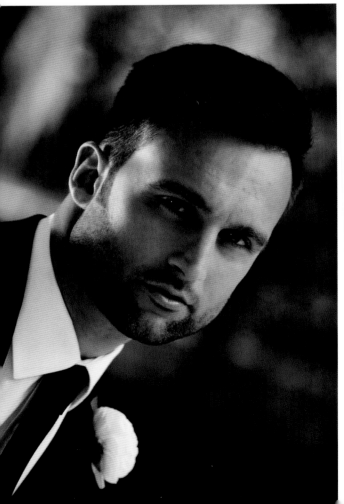

Working with grooms is different than working with brides. For one thing, grooms are sometimes less interested in the photography and that can make them less cooperative. Like the bride, the groom faces numerous stresses on this important day. He is leaving behind the single life, he's nervous, he feels the pressure of being in the spotlight—and on top of it all, he may have a serious hangover from the night before. (It happens!)

If a groom seems nervous, before shooting I try to engage him in a conversation about something other than the wedding—sports, business, travel, or any other shared interest.

The weddings that have been the most challenging for me were the ones where the groom and groomsmen showed up drunk. The wedding may be thought of as "the bride's day," but the groom is half of the event. When he's not in good shape, it can be difficult. Even in this situation, though, you will have to find a way to work with the guys. One line of reasoning that sometimes gets through is to remind the groom that he and the bride invested a lot of money in their photography—and that the bride is certainly looking forward to making a beautiful album.

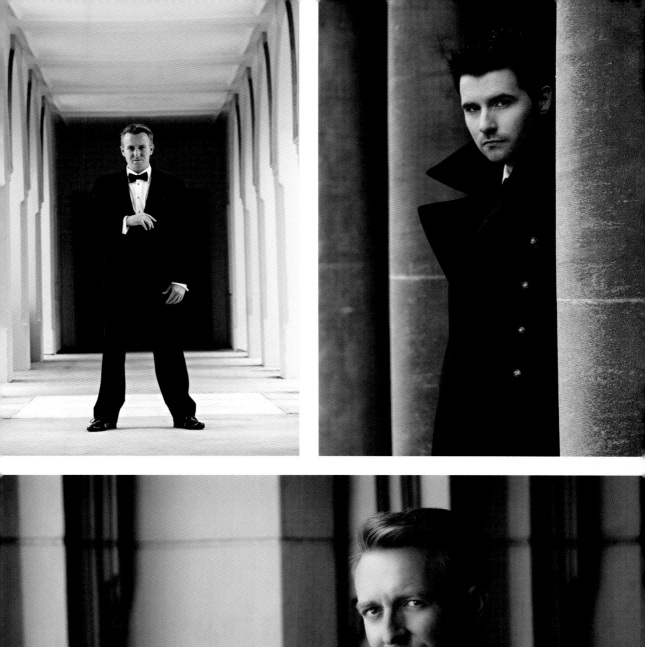

27. STYLE AND IMPACT

I hope we are all trying to give our clients something fresh and new—something the studio down the street isn't providing them. Now, more than ever, we need to stay on top of our photographic expertise and push ourselves to innovate. Everyone now owns a digital camera—and lots of folks are getting their images printed at the local WalMart. We need to take back our livelihood and what we all do best: provide high-quality images that will last forever.

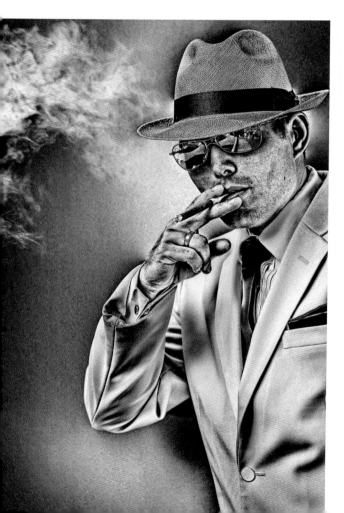

POSING AND LIGHTING ARE BACK

With confidence, I am happy to report unposed, ambient-only images (often called photojournalistic or lifestyle images) no longer rule the day. Posing and lighting are back!

That's good news for professional photographers, because posing and lighting are things that most "Uncle Joe" shooters can't do. Flattering posing techniques and creative lighting patterns will have your clients coming back for more.

If you are trying to better yourself as a photographic artist, you have to start seeing and thinking like one—and posing and lighting are critical to that. I learned a long time ago, from my mentor Don Blair, that you have to learn how to see and paint with light. He also taught me how to successfully use negative space to create impact. Those are both lessons you see put to work in these images.

THE GROOM: MAKING AN "IMAGE STATEMENT"

This groom loved his hat and wore it throughout most of the wedding day. He also loved his cigar, so I decided to make those elements part of his "image statement" for his special day.

Early morning ambient light was skimming across the column in the background, which gave me a smooth transi-

tion of light. (And, in the color images, the gold color of the column really complimented his attire.) There was quite a bit of reflected light coming from the building across the street so I didn't need an additional light source. I metered under his chin. (*Tip:* I shot the smoke image at a slower shutter speed so the smoke would blend throughout the composition.)

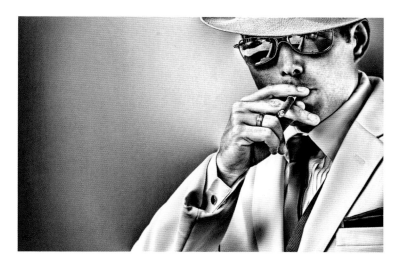

I carefully made sure the groom was placed so there was plenty of room for me to back up with a Canon 70–200mm lens. Then, I had him lean so that his shoulders were slightly angled (*facing page and top right*). Then, I had him turn his head until his far ear disappeared from view and I could only see just a sliver of skin near his camera-left eye. This is called a two-thirds view of the face.

To keep the bottom-right image looking cool, I lowered his hat (making sure I could still see his eyes) and turned his body square to the camera. I got down as low as I could and shot at an upward angle to make him look tall and bold.

I finished the images using software from Lucis Art and the Nik Collection.

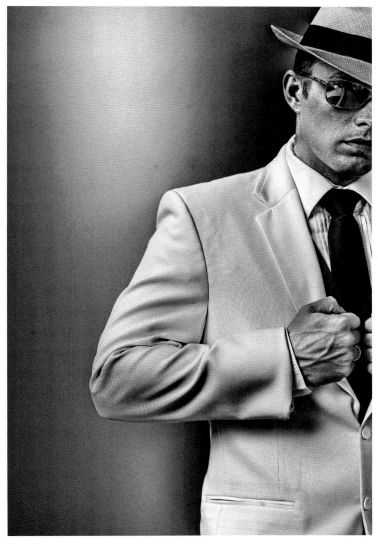

28. ENVIRONMENTAL

To help couples decide whether they want environmental portraits and, if so, where they'd like them taken, I display sample images from various appropriate locations. When discussing environmental portraits, it's important to stress that these do take some extra time for you to set up—and since they are shot in uncontrolled locations, there's a chance of the dress getting dirty (but you'll do your best to make sure that doesn't happen). In case bad weather makes the couple's chosen location impossible, you should also discuss some indoor alternates.

THE ROMANTIC SESSION

Not all couples' ceremonies or reception venues are the best environment for romantic images. Therefore, we also offer a "romantic session" in addition to the engagement and bridal sessions that we provide for our clients.

This "romantic session" can be done before or after the wedding day (depending on the couple's preference) with the couple in their wedding day attire and at a location the couple chooses. Doing the session after the wedding day is a good option for any bride who is worried about getting her dress dirty.

> **❝ In case bad weather makes the couple's chosen location impossible, discuss some indoor alternates. ❞**

It's a great opportunity to capture the real relationship between the bride and groom because they are relaxed and not in the midst of dealing with the stresses that the wedding day brings. These sessions also give us the time we need to refine each look fully and get more creative.

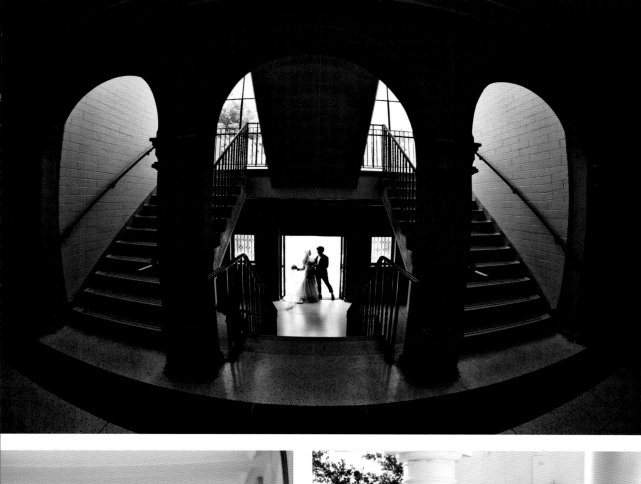

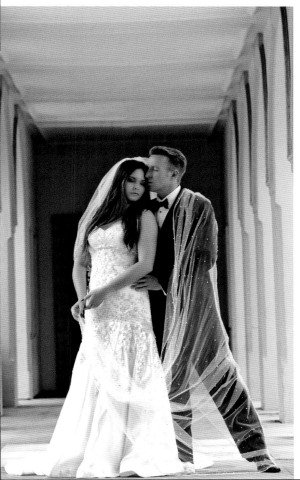

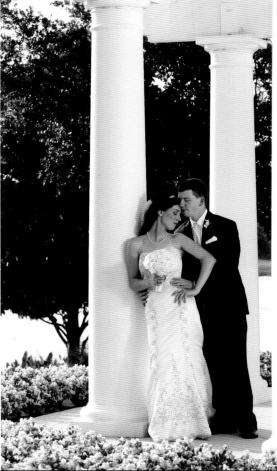

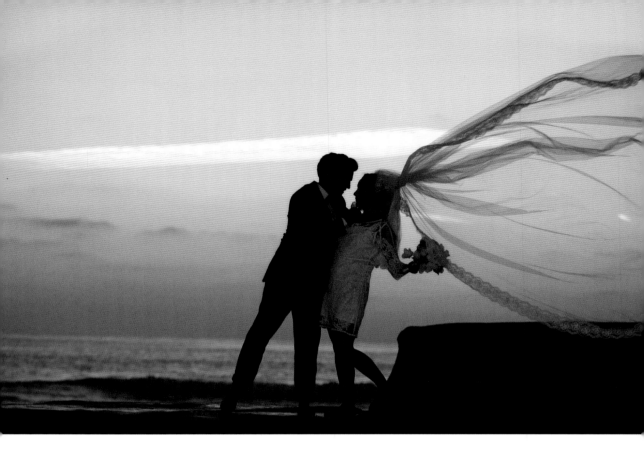

We can also do fun photographs (walking barefoot on the beach, horseback riding, dancing in the moonlight) that aren't feasible on the wedding day. This provides more variety for the couple's album and can generate additional sales.

TIMING

The usefulness of a particular location can change throughout the day and from season to season. In Florida, where I live, there aren't too many seasonal changes to worry about aside from rain. In other climates, the changes can obviously be quite profound and are something to take into consideration when planning environmental portraits. You should also take into account the time of day and the kind of light you will be working with. The traditional "golden hours" of early morning and late afternoon will provide the most desirable lighting conditions—but be prepared to shoot throughout the day and have strategies for working with all kinds of natural lighting situations.

❝ This provides more variety for the couple's album and can generate additional sales. ❞

29. COMMUNICATING WITH YOUR CLIENTS

CONTRIBUTOR: Patty Bradley

In recent years, the world has come a long way in terms of communication. We carry on conversations in different ways through mobile devices and social media. It is no longer uncommon for people to expect businesses to respond in much the same way that they expect to interact with their friends and family. The question is: How do we manage all these means of communication?

EXPECTATIONS

In 1991, when I opened my first photo studio in a small town in the Midwest, one of the first forms of advertisement I used was a phone book ad. The day that the phone books came out and were distributed, my expectation was that my phone would start to ring because I paid for advertising. This was in the days prior to the Internet, so a website was not in the picture of a business plan.

I soon found out that I had to get out into the community and start to interact with others. I volunteered and worked on networking with other businesses that fit with my studio. Soon, I found new clients and the business blossomed. My business

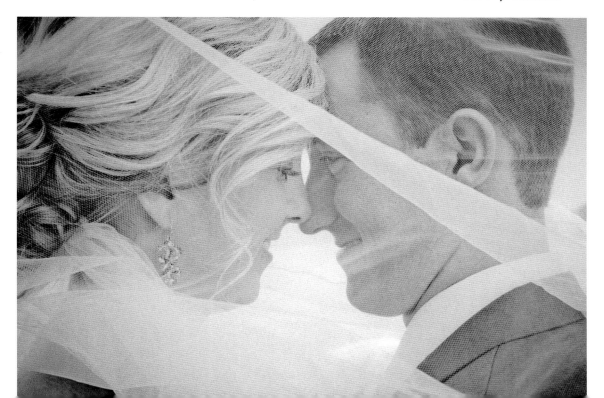

plan also evolved as I found out more about my own personal strengths and weaknesses as a portrait photographer.

Today, starting a photography business is not so different. Strategically, networking is still the best and quickest way to build your client base. Find the people in your life who believe in your ability; they could be your family, your friends, or coworkers. Find out who *they* know that could benefit from your services, and build a strong portfolio if you have not done so. Build an attractive website and make sure it links to the most popular social media sites. Choose to spend your time with the social media that helps your business—particularly Facebook, Twitter, and Instagram. And remember to include Google+ because it is a powerful SEO builder for your website.

Networking with other businesses in your real or online community is also critical. There are countless organizations (sports clubs, youth groups, etc.) asking for volunteers and nothing is more satisfying personally than giving back to your community.

Meet-up groups are another source of networking. You can download the Meet-ups app on the Apple App Store or Google Play and search for categories that interest you. If you are looking to connect with other businesses that you want to work with, you might find other motivated individuals who are looking to connect with you. For example, I was looking to work with a talented makeup artist and hair stylist, so I used meet-ups to get introduc-

tions. Through them I found a great person to assist with my clients' styling needs.

INSPIRING OTHERS

I let go of phone book advertising a few years ago and replaced it with a blog. Instead of spending dollars on advertising, I looked at this as sweat equity investment in my business. For an existing studio, this is a great way to expand your current business—and for those just starting, it's a way to expand your social media network. Maintaining a well written and well illustrated blog requires some dedication, but it's one of the best ways to invest your studio's marketing dollar. And blogs are easily tied to other social media sites.

One of the best is Pinterest. Creating boards showing creative posing, prop ideas, and clothing choices is a fun way to explore ideas with your clients and answer some of their pre-session questions. As clients involve themselves in the process of the session, it builds more value into the images. Pinterest also brings opportunities to show your clients products like albums and wall portraits. This is a very important step, especially in building a relationship with the client.

It also helps to have a survey to record the client's details and make a list of possible items that would part of the final sale. The more organized you are prior to the sales consultation, the easier it will be for the client to finalize their portrait purchase. You are providing them with a premium customer service that will be appreciated, and the reward for your efforts

will be more session bookings through customer referrals and return clients. That is the sign of a healthy business.

COMMUNICATION

I believe we are better able to engage new clients with a well built online presence and active social media, but the cost of this total engagement is your commitment.

Today's clients may expect you to be open to them in other ways than just a conversation on the phone. Many clients also expect to be able to text you at their convenience. This is especially true of millennials who have grown up in a world of texting and Instagram.

It is up to you to manage this—and, by all means, let clients know it is okay to contact you at their convenience, but you may answer only during business hours. I know of photographers who will answer text messages any time of the day or night and that is totally fine if you set that

expectation and can manage it and your personal life. Just remember to find your balance; do not put your family second. If you enter this business hungry to work hard and able to be creative and communicative, you will find yourself busy.

I have found that email is still a very basic business essential. It is a good idea to create a standard studio e-mail address (such as hello@ABCstudio.com) and a wonderful signature file that shows off your business information in an attractive way. Keeping in touch with your clients regularly is one of the best ways to promote and maintain your business. Creating a calendar of e-mail communication to all of your clients is a good way to introduce specials, promote your blog, or just to say how much you appreciate them.

On-line galleries are another important communication tool for connecting with additional parties—especially grandparents and other relatives. For portrait

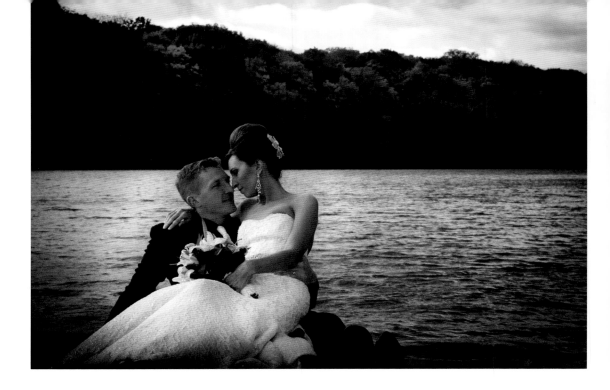

work, this should only be offered once the sales consultation is complete. It is important to manage the selections and give the customer the opportunity to choose the images they like best. This will make them more likely to share the images with others. For weddings and events, the total image gallery is necessary. However, we do offer, for friends and family members, an additional gallery of bride-approved images with special pricing.

Finally, one more important way of letting clients know how much they mean to you is by mailing them a thank-you card.

It is an especially rare moment these days when you receive communication by mail, and this is just one more "special touch" to show your appreciation to your clients.

THE MOST IMPORTANT COMMUNICATION

There are many opportunities to help your clients by using your tools of communication. However, the most important is your ability to communicate through your photography skills to create beautiful portraits. Always improve by learning all you can—and thank those who mentor you. (Thank you, Rick Ferro!)

Patty Bradley is graduate of Hawkeye Community College in Waterloo, Iowa, where she attended a program founded by Don Lohnes and American Color Imaging to train portrait and commercial photographers. During her career, Patty has photographed over 1,250 weddings and thousands of portraits. She continues to work as a marketing consultant, helping businesses build their brands.

30. WHAT'S YOUR MESSAGE?

The portraits you create are the way you make your statement as a photographer and as an artist. Therefore, you should be conscious of the message you are creating every step of the way.

NATURAL AND ELEGANT

In this image, the natural and elegant composition makes just the right statement for my style. The veil was styled to fall neatly away from the face, creating a look that is soft. The flowers are in the frame but kept in the lower part of the photograph so that they do not overwhelm or interfere with our view of the bride's face.

ROMANTIC

The bride was posed with her face in a two-thirds view, turned toward the light. I posed the groom in a profile, then had him lower himself carefully so

that he was slightly higher than the bride and his lips were at her eyes. Closing the eyes is a key to creating romantic portraits.

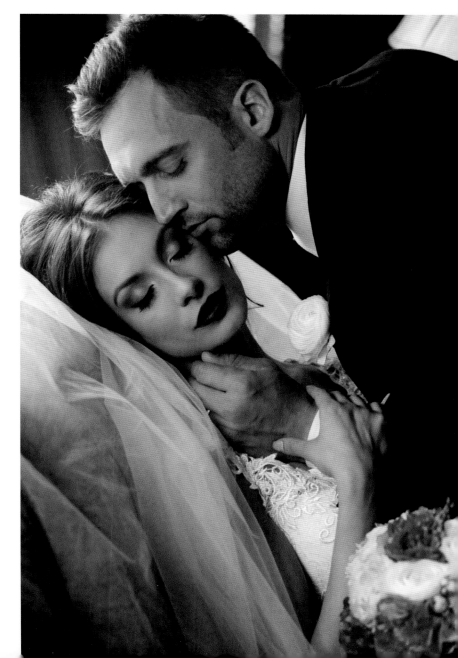

31. OFF-CAMERA FLASH

Adding off-camera flash gives you a subtle way of illuminating a person's face. It's a soft way of adding a layer of light to an already beautiful exposure. If it's done well, you won't be able to tell flash was used (unless you zoom in and look closely at the catchlights).

AMBIENT LIGHT PLUS FLASH

I start by getting the ambient reading from the meter, then I dial my flash (in manual mode) to whatever power output I need, typically somewhere from $\frac{1}{16}$ to $\frac{1}{4}$ power. I'm just adding a little power to open up any shadows. I may adjust my exposure slightly, because I did add a little more light, but the end result is spot-on.

15MM LENS

When using a 15mm lens with off-camera flash, the most important thing to know is to stay as close as possible to the client. The 15mm will see everything including your feet if you're not careful. I'm usually only 3 to 4 feet away from the subject.

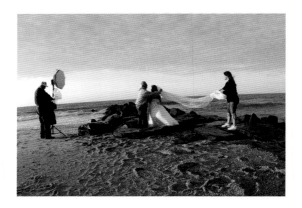

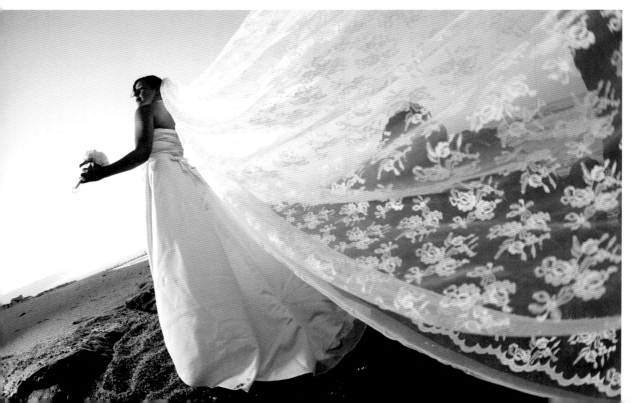

32. POSITION, POSE, LIGHT

osition, pose, and light. Those three concepts sum up my approach to creating every portrait. It's that simple. If you really slow down and think about those words, you might find a sense of calm in your process. That, in itself, can be important to your success. After all, clients can feel if you're nervous or unsure. Working through each of these words, step-by-step, can bring a sense of confidence to your shooting. Here's how to do it.

POSITION

Before the session, take the time to scout out a location or position where you think you'll have the most success. Evaluate the position of the sun at the time of day when you want to shoot and decide whether you'll need to add or modify the lighting. Don't wait until the day of the session to make this decision.

POSE

I always have at least ten different poses in mind before I start shooting. There's no excuse for being unprepared. When clients hire you, they expect a reasonable quantity and variety of images. If you're not comfort-

able keeping that many poses in your head, print out ten different poses and keep that sheet handy so you can copy or adapt the poses.

LIGHT

Carry enough lighting gear—and make sure you have backups. Your client has set aside time to have their portrait made and poor available light should never be an excuse for poor images.

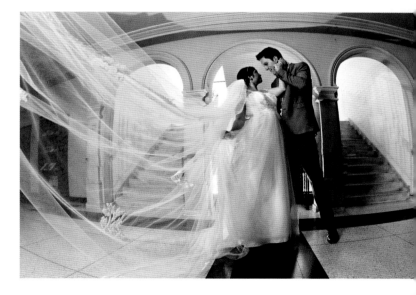

33. CAPTURING EMOTION

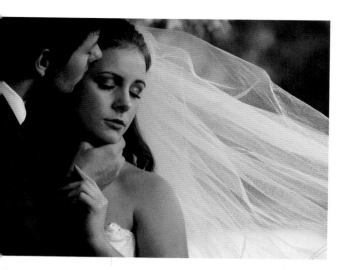

D on't get frustrated if you find it challenging to capture images that feel truly emotional. To be honest with you, it took me years of practice to learn how to do it consistently. I studied and practiced on my neighbors, my wife, and anyone who would let me photograph them. I wanted so badly to create truly romantic images—and one day I finally got it!

POSING TIPS

Looking my own work and that of different photographers, I have two important tips to give you. First, a two-thirds view is a powerful pose. (This where the face is turned so that you see only one ear and just a thin strip of skin beyond the far eye.) Second, a profile pose also has a high degree of impact.

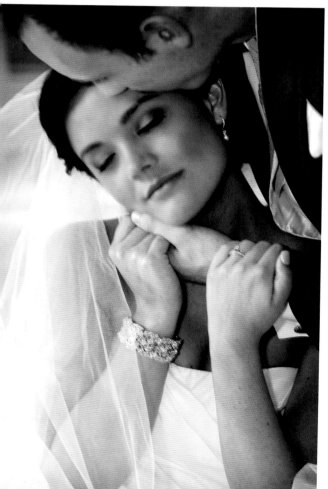

As you can see in most of these portraits, I have mixed a profile of the groom with a two-thirds view of the bride. Most often (see the images to the left), I shoot tight into the groom's head and let the bride be the center of attention. I tend to elevate him slightly, shoot from a low angle, and tilt the camera for a stronger composition.

You can reverse these facial views for another strong look—or even shoot both the bride and groom in profile.

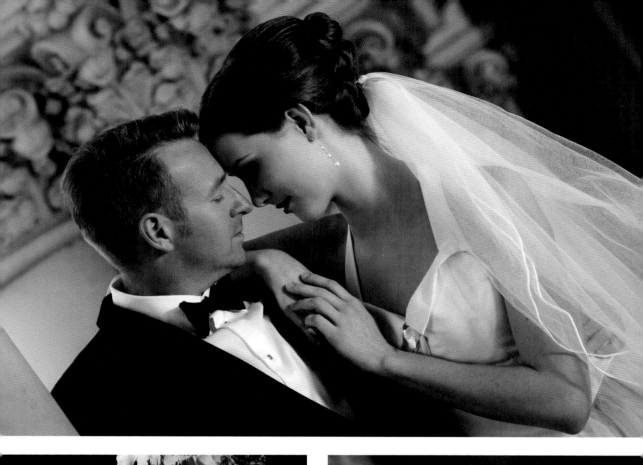

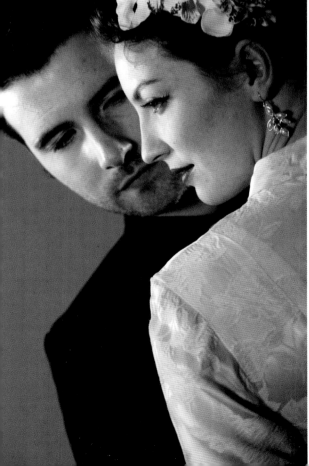

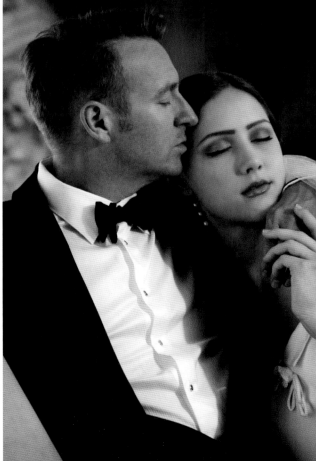

34. LIGHT LARGE GROUPS

Believe it or not, building a large group is not as hard as you think. There are simple steps I take to build and light my groups.

LOCATION AND BACKLIGHTING

First, I scout out the location I think will work. I want to make sure I can place the subjects in a spot where the sun is directly *behind* them.

POSING

Next, I start to build the group. In this example, I began with the grandparents, seated at the center of the composition. Then, I added their children and their spouses. For a larger group, I would continue adding people according to their relationship—aunts and uncles, cousins, etc. To balance the group, I usually request that some folks get down low.

This prevents my group from having that "standing straight in one line" look. You really want everyone in the group to have their own organized spot so that the image looks nicely posed, not cluttered.

METERING AND ADDING LIGHT

Next, I will take my meter and place it under the chin of a few folks to get an overall reading of the ambient light that is falling on their faces.

I believe in having light in the eyes, so I will position my Quantum light off to the side at a 45 degree angle. I will also have another Quantum flash on the camera.

For these images, I work in manual mode, so my main light (the off-camera flash to the side of the subjects) is typically set at ¼ power. The fill light (the on-camera flash) would then be set at ⅛ power.

In this case, my ambient reading (before I added the lights) was f/5.6 at 1/60 second and ISO 200. Because I added more light, I adjusted my final exposure settings to f/6.3 at 1/16 second and ISO 200. (Check out page 22 to see the final image.)

35. SILHOUETTES

LIGHTING AND EXPOSURE

Silhouettes (or near silhouettes) can be accomplished anywhere you can find a strong contrast in light levels.

You'll want the couple or bride in low light with bright light on the background. Silhouettes can be done outdoors against the sky, inside against stained glass, or in an open doorway. Look for a window or other background with few distractions—especially trees or branches that will make it hard to appreciate the silhouetted shape of your subject.

Place the meter with the dome out aimed to the bright light on the background or coming through the window. It's that simple.

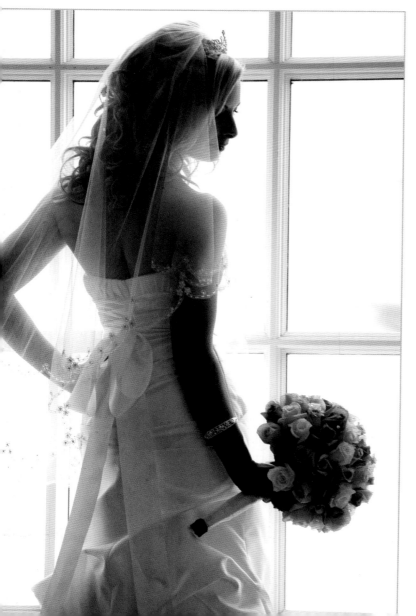

LOCATION AND POSING

In my silhouettes (this page and next three pages), notice that no one is just standing up completely vertical. Especially in these shape-driven images, we must put emphasis on body language! I call it "dance," which really means putting the body in a position where it has strong lines. You will be surprised how you can make someone bend! Have you ever looked at a poster from *Gone with the Wind*? Every image has dance. You'll find that a beautifully posed silhouette can be tremendously meaningful and elegant.

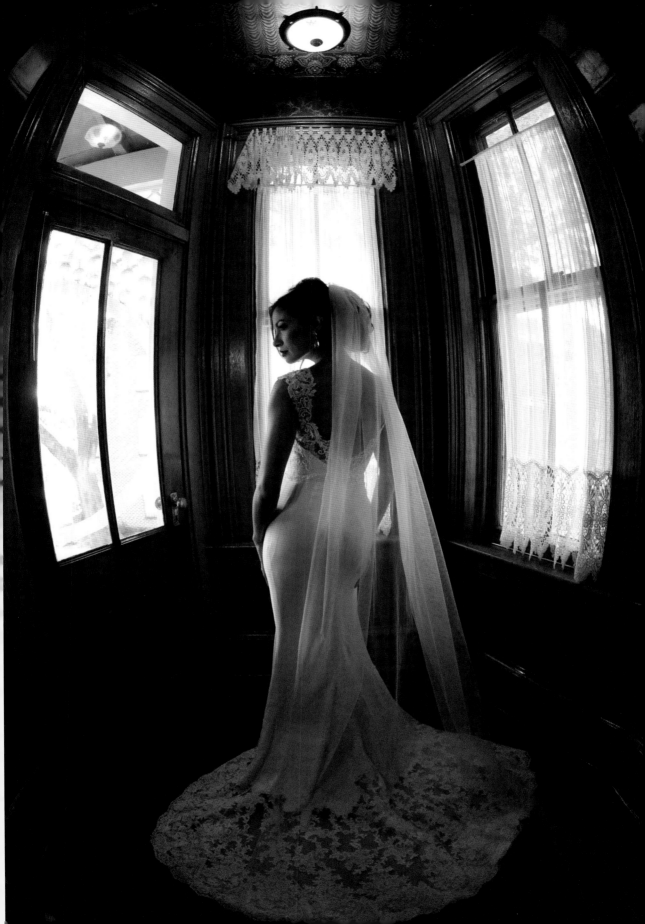

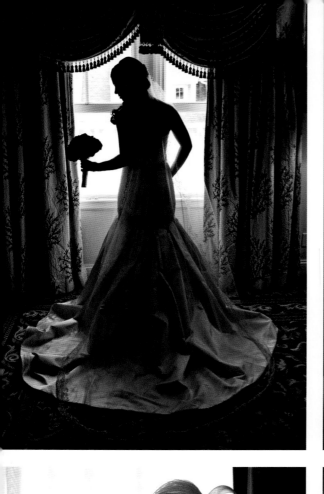
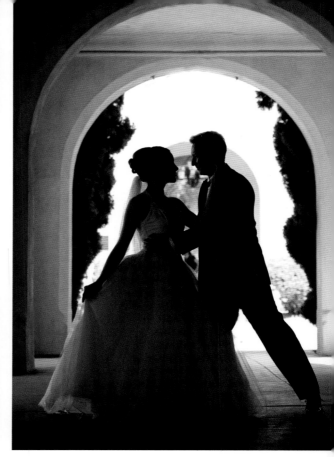
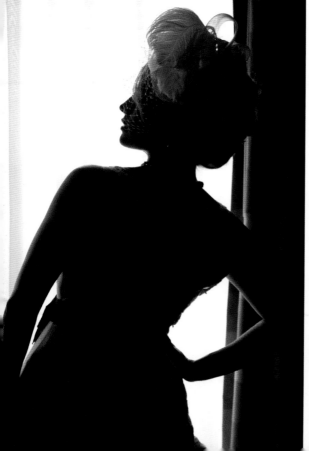
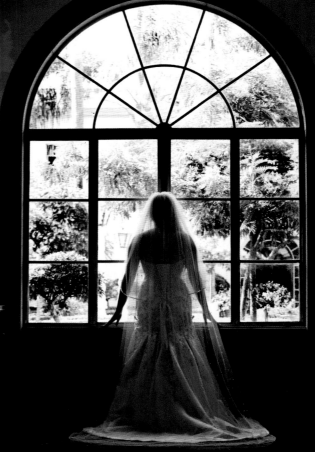

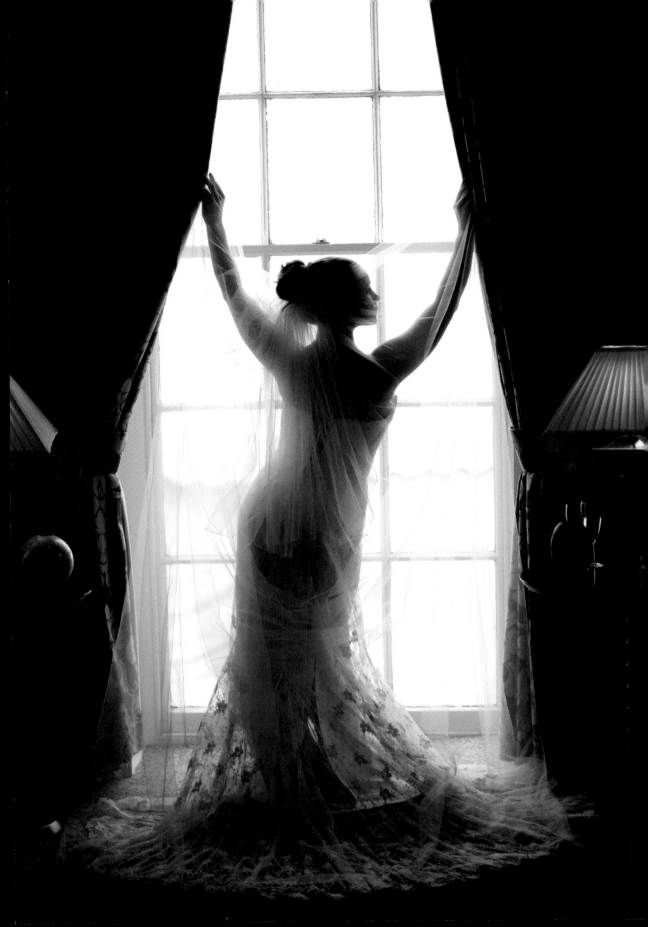

36. WINDOW LIGHT

When shooting on location, be on the lookout for great window lighting opportunities. Window light functions much like a softbox in the studio, giving you soft, flattering, directional light. To adjust the intensity and direction, simply adjust your subject relative to the window.

METERING

The meter is placed under the subject's chin with the dome facing the lens of the camera to record the accurate exposure. With my Canon Mark II on a Bogen tripod, I shot this at f/5.6 and 1/60 second at ISO 400.

CRAMPED QUARTERS

Here, the window area was small; there was not a lot of room to maneuver. I turned the bride as much as possible so she would look comfortable without being square to the camera. Her face should be the emphasis of the image. I also lowered the flowers just enough to be part of the scene and still maintain nice detail in the shadow area. In a shot like this, the architecture really brings it altogether so be sure to frame it with plenty of space around the bride.

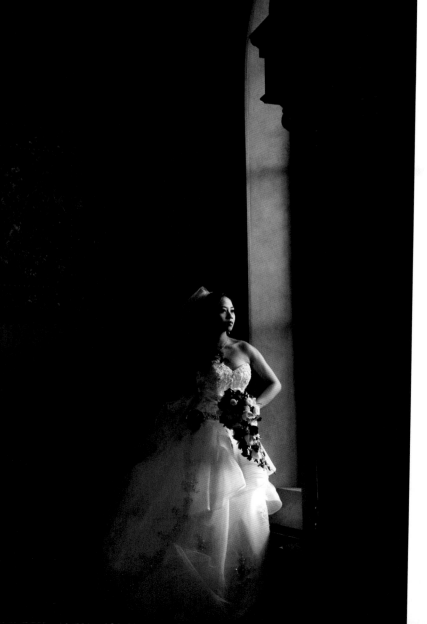

Custom White Balance

When shooting indoors with window light, you may actually be working in a mixed-light situation with room lamps or other ambient sources that will contribute to the exposure. Because these light sources have different color temperatures, they can result in subtle (or obvious) color shifts on your subject or background. These are often far less obvious to the naked eye than they will be to the camera or in your final images.

Using a custom white balance setting can help you make the best of this situation. Each camera is different, so be sure to reference your camera's manual for how to do this. You will also need a white/gray card or a custom white balancing device like the ExpoDisc.

Focusing

When focusing on a wide scene like this, it imperative that you use the camera's focus sensors to lock in on the face. That's the reason for taking the photo!

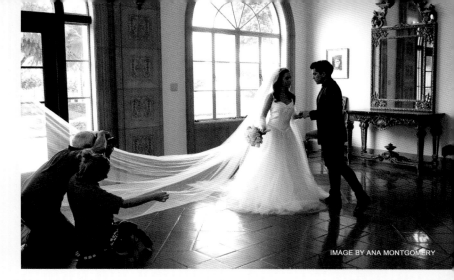

IMAGE BY ANA MONTGOMERY

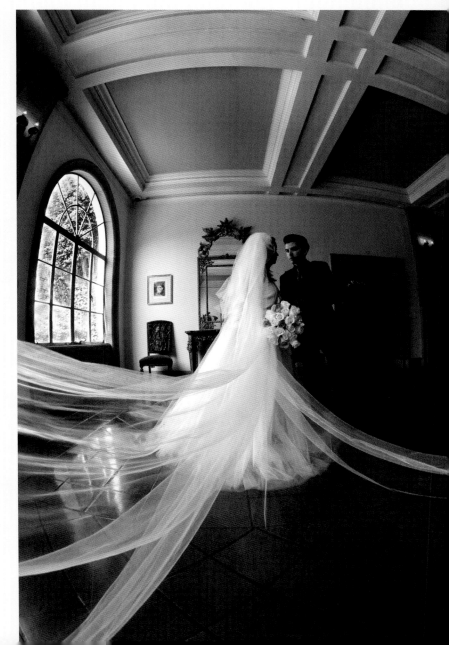

37. LED IS THE FUTURE

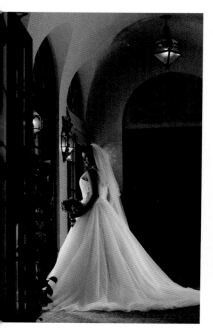 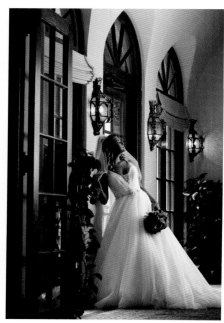 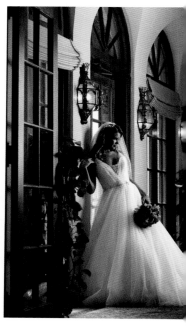

I firmly believe that we are all headed to using LED lighting as the norm in the near future. It produces no heat, it's bright and simple to control, and the price is right. Manufacturers can't make this product fast enough! Even Disney has covered Cinderella' Castle in the Magic Kingdom with 250,000 LED lights.

WHICH KIND?

I wanted to address this phenomenon because many of my images are now shot with LEDs. I'm not going to tell you what LED lights are the best or what brand is better than another, because I've come to a conclusion that it doesn't matter which one you work with. If you understand lighting—the direction of light and where to position the light—then you're on top of the game and won't have much trouble transitioning to shooting with LED panels!

TIPS AND ADVANTAGES

I will say that I usually have to use a higher ISO with LEDs than when I'm using studio or portable flash units. The reward is instant, though, when you see it on the back of your camera. With LED, what you see is what you get. What a thrill! With film we waited four days to see our proofs; now we see everything instantly.

38.
SOFTBOX LED

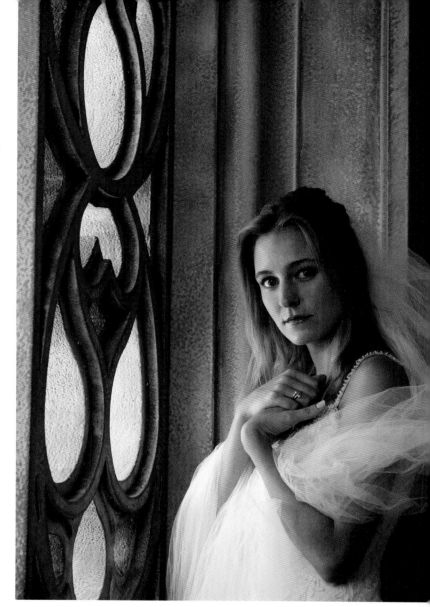

It can't get any simpler than this lighting effect! I simply placed my LED lighting inside a softbox. Why? I wanted to soften the light even more, so it would create the illusion of window light when I placed it behind the carved openings in this wall. In addition to the main light, which was placed right up against the backside of the fake window, I added a second LED light in a softbox for fill. This opened up the shadow areas.

I kept my subject quite close to the light, with a three-quarter view of her face and figure relative to the camera. I didn't worry about showing the whole wedding dress. Once I metered the light, I had her go into different hand poses for some variety.

39. LIGHT A SEATED BRIDE

In this photo exercise, you can see my layout for LED lighting. Before I get into explaining the setup, though, I want to make of point of noting that this is no different than if I were using flash. The LED lights can be set up exactly the same way.

SETTING THE LIGHTS

LED lighting is extremely popular now, largely because of the ease of "what you see is what you get" shooting. However, I still see a lot of photographers placing the main light next to the camera and the fill light on the other side of the camera. That was great when we were all using film, but those days are quickly coming to an end! Digital is super sensitive and you don't need that much intensity. I prefer to layer my light. This exercise will take you through the process.

STEP ONE

The bride sits in a general position and I place the background light. I set that light one stop less than the main light. In this case, that puts it at f/4.

STEP TWO

I place the main light at a 45-degree angle to the face. Here, the main light was set to f/5.6

STEP THREE

The fill is set on the same side of the camera as the main light, but closer to the camera. For this sequence (*facing page*), it was at f/4 (one stop below the main light).

STEP FOUR

I place a light to come in from behind the subject on the shadow side. This light, called a kicker, adds highlights to improve separation. Here, I have it set at f/4, the same as the fill light.

STEP FIVE

A reflector is placed opposite the main light to help bend the light around onto the shadow side of the subject.

STEP SIX

When all the lights are in place, it's time to meter the subject. Place the meter under the chin and point it toward the camera.

That's it! You're ready to start trying out some posing variations.

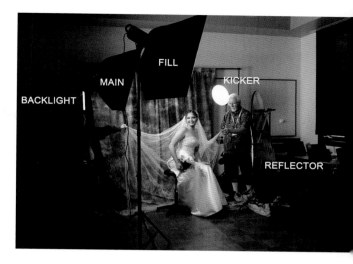

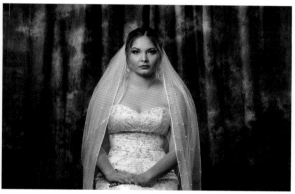

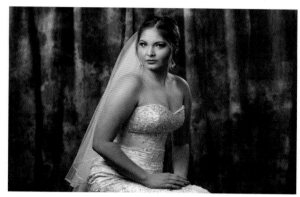

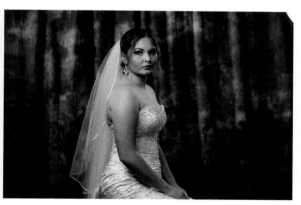

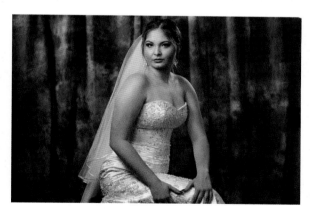

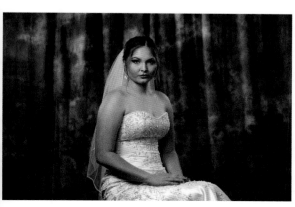

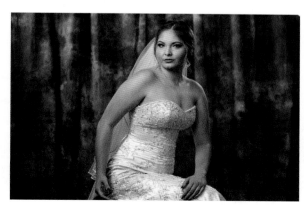

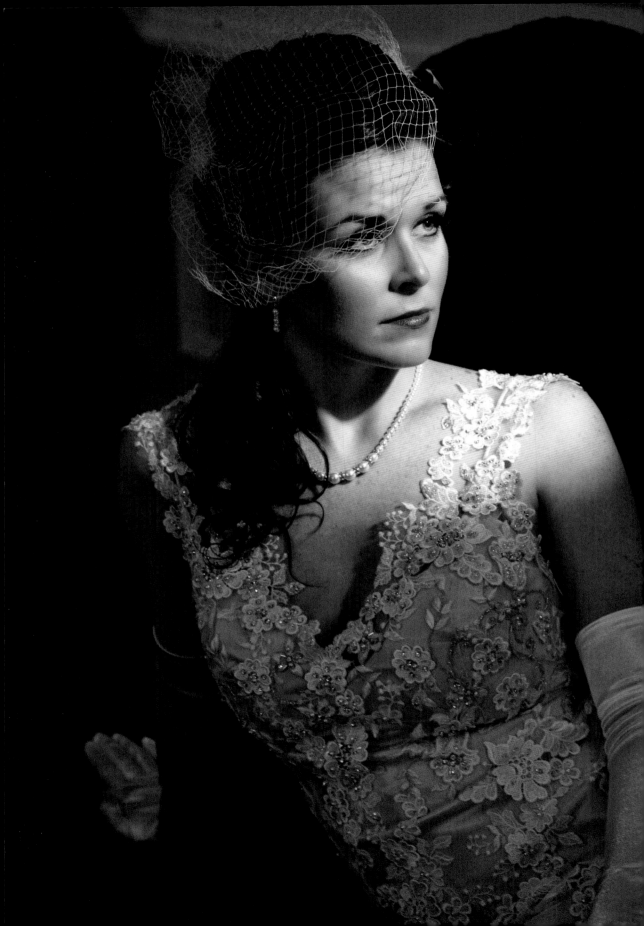

40. LED SIMPLICITY

A SPOTLIGHT EFFECT

For the dramatic image on the facing page, I used an LED but modified it to work like a spotlight. There are a number of ways to create this effect. One would be to go out and buy a special LED spotlight. Alternately, you could make a baby snoot out of cardboard and fit it over the head of a good LED flashlight (one with some output controls). Either approach will work.

To pose this shot, I had her drop her shoulder and lean back on her rear hand as far as she was comfortable. This created a nice diagonal with her body. Then, I had her turn her head toward the main light for a two-thirds view. Finally, I made sure her eyes had a pleasing direction, looking slightly up. I also raised the camera to get a little more impact.

SOFT AND SWEET

For the image below, I used two things to my advantage. First, I had her seated at a posing table. Second, I wrapped her train over the table to create a high key look. It's very easy to light an image like this! The white fabric surrounding her brought in all the bounce light I needed, so the only lights I added were a main light above her to camera-right and a kicker light behind her to camera-left.

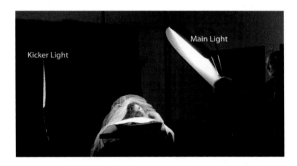

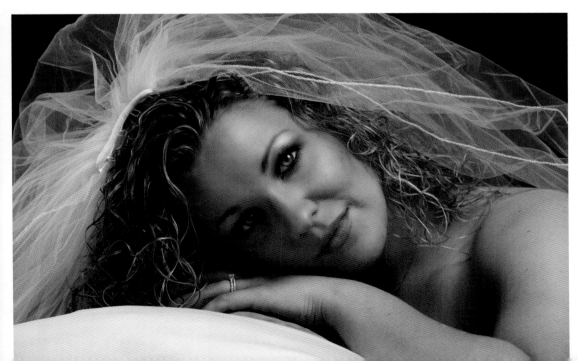

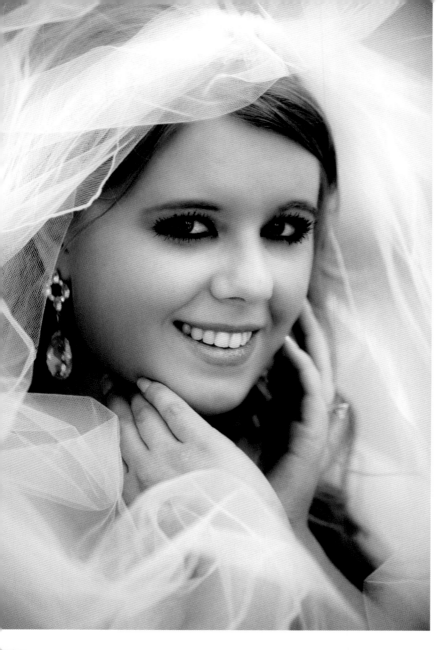

41.
INDRA
500 LED

The Indra 500 from Phottix is actually a strobe that syncs at shutter speeds up to $\frac{1}{8000}$ second, but it has a very strong LED, too. This is designed to be used as the modeling light but you can shoot with it, too.

For this image, you can see that I had the light in a small softbox and had my assistant bring it in nice and close to the subject. I made sure I could see pretty catchlights in her eyes.

Then, I placed my meter below her chin and pointed it back toward the camera for the perfect exposure.

I did a little hand posing, and shot the image. In postproduction, I used Nik Collection filters (skin softener and black & white) to finish the image.

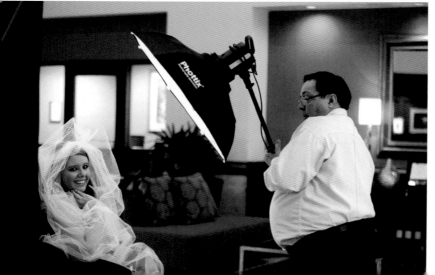

42. ATTITUDE REFLECTED

CONTRIBUTOR: Annette Gregory

A small group of photographers and I had a chance to work with this model and one of our group members suggested this location with a reflection pool. Not having seen it before, I had completely different ideas in mind that changed the instant I saw the location.

Immediately, I saw the arches and thought about framing. I knew that the position of the pool would do well with a balanced image, so centering the subject was called for. I also wanted to make use of the sharp, high-contrast light, so rather than scrim the subject I simply had her wear sunglasses.

Once I started looking at it through the lens, I made sure that the reflection was also framed within the water. I felt it gave the image more balance. We went through a variety of poses, but when I asked her to arch her back with a little attitude and then look over her shoulder at the camera, I immediately knew this pose would be the one I wanted.

In postproduction, I saturated the colors a bit, and toned down the highlights. I also refined the reflection in the windows and did some minor straightening. I shot this on a Canon EOS 6D and an EF 70–200mm f/2.8 IS II lens at 110mm. My exposure, made with the available light only (no modifiers) was f/5 and ISO 100 at ¹/250 second.

Annette Gregory is a professional wedding and portrait photographer. Her studio, BeechTree Photography, is based in Mentone, CA.

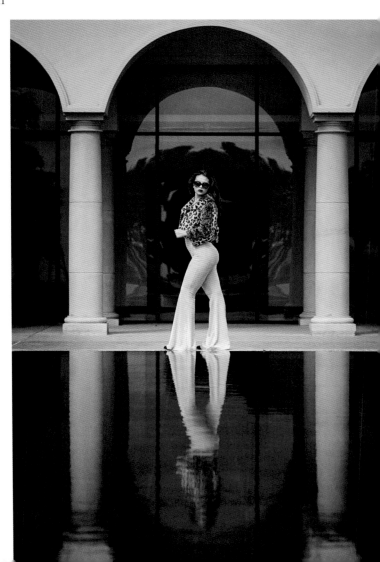

43. STUDIO BRIDAL

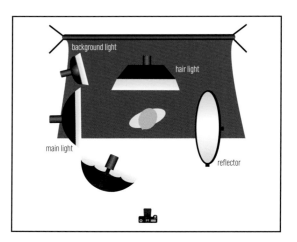

STYLING AND POSING

For a nice full-length portrait, the dress has to be fixed properly and with great detail and care. Turn her head toward her high shoulder or toward the main light. The flowers here were quite large but we have to work with what we have in front of us, so I lowered them enough that they didn't block her bust.

LIGHTING

As shown in the diagram, the main light was a softbox set at f/5.6. For fill, I used an umbrella at f/4. The background light was set at f/2.8 and the hair light was at f/4. A reflector opposite the main light helped wrap the light around to her shadow side.

METERING AND SHOOTING

The Sekonic meter was placed under the subject's chin with the dome facing the lens of the camera to record the accurate exposure. Here, that was f/9.5 at 1/60 second and ISO 100. I shot the image with my Canon Mark II on a Bogen tripod. I used a 50mm lens and a custom white balance setting.

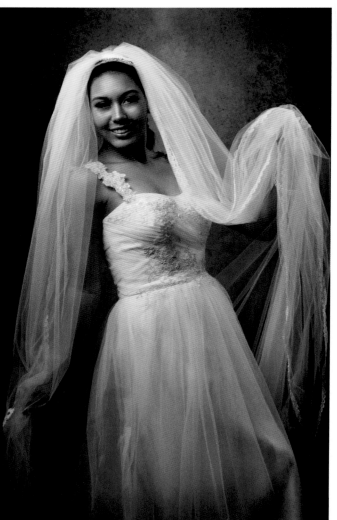

44. LOCATION BRIDAL 1

POSING AND COMPOSITION

Brides today look at magazines and want that style in their photographs—but when it comes time to do it, they always ask, "So what do you want me to do?" I had the bride gently clasp her hands and lean only her upper body back for this striking pose. Lifting her dramatic red veil enhanced the composition and added to the drama.

METERING AND EXPOSURE

We shot this image outside on an overcast day with the sun overhead. The Sekonic meter was placed under the subject's chin with the dome facing the lens of the camera to record the accurate exposure. Here, that was f/5.6 at $^1/_{60}$ second and ISO 100. I shot the image with my Canon Mark II on a Bogen tripod. I used a 70–200mm lens and a custom white balance setting.

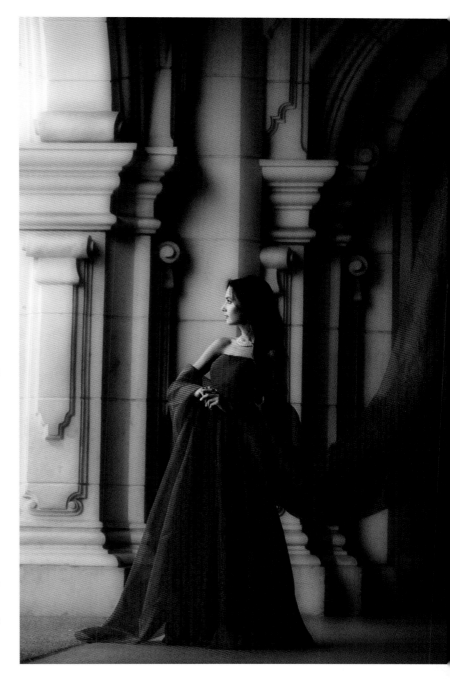

45. **LOCATION BRIDAL 2**

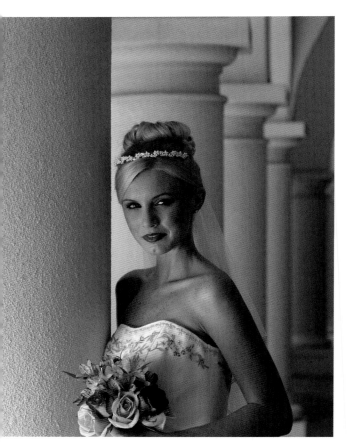

LIGHTING AND EXPOSURE

I shot this image on a sunny day, under the shade of an outdoor colonnade. This blocked the overhead light and allowed me to create a nice look using just a reflector to bounce some of the sunlight onto the bride's face.

> 66 Use a long lens to compress the scene and accentuate the relatively shallow depth of field. 99

The Sekonic meter was placed under the subject's chin with the dome facing the lens of the camera to record the accurate exposure. Here, that was f/5.6 at $\frac{1}{60}$ second and ISO 100. I shot the image with my Canon Mark II on a Bogen tripod. I used a 70–200mm lens and a custom white balance setting.

COMPOSITION AND POSING

When setting up an image like this, lining up the columns is imperative. Use a long lens to compress the scene and accentuate the relatively shallow depth of field. The bride should hold the flowers just high enough that they can be seen; you don't want them to distract from the viewer's appreciation of her face.

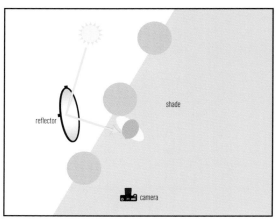

reflector

shade

camera

46. STORYTELLING DETAILS

Providing professional wedding photography involves more than creating outstanding portraits of the bride and groom—it's about documenting an entire event.

TELLING THE WHOLE STORY

In order to create a special day for their guests, the couple will have spent a great deal of time selecting just the right locations, food, flowers table settings, centerpieces, and more. These aren't small (or inexpensive) decisions, and they need to be documented. After all, the details often define the "feel" of the event. The bride and groom will appreciate your effort to capture all the details—especially since they may be too busy on the day of the wedding to actually enjoy how everything looked!

PROMOTING YOUR WORK

Your detail photos can also be used as a public relations device. You might be

tempted to refuse when a caterer or other wedding vendor asks you to make some 8x10s for them. I understand that reluctance. When I was new in photography, I tended to give away the farm, donating my time and money to make the vendors happy. One day, I decided to pay a visit to one of the caterers I'd given images. When I asked where my images were being displayed, I found out they were in a drawer and nobody was even looking at them!

I was over that real quick—but I didn't want to lose the caterer all together, so I put together a beautiful 11x14 poster with about five different images in a collage. I also framed it. But before I added glass to finish it, I took it to the caterer and asked them to write a comment about what I did. Lo and behold, the comment was great—and the poster now hangs on their wall.

Why? Because now it's personalized. It has their name on it, so it represents not only *my* work but also *their* work. It has a definite "wow" effect! (And do you think they are recommending me now? You bet!)

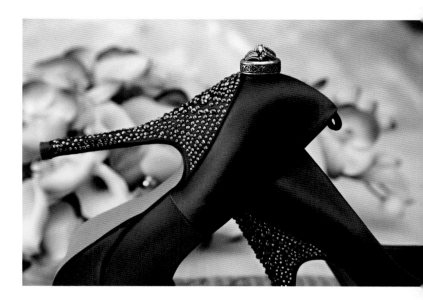

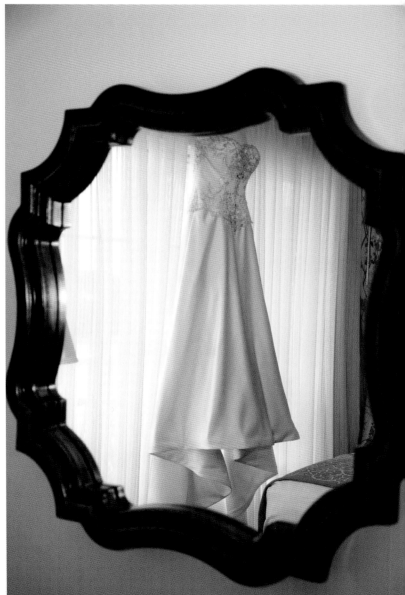

47. NEGATIVE SPACE

Including some negative space (areas not occupied by the subjects themselves) can make for more eye-catching portraits. In my experience, these images are big sellers.

Look for places where you can put your subject(s) off center and still fill the rest of the frame with interesting and artistically relevant material. A boldly colored wall or interesting background texture works well. If you can add a leading line (like the bride's veil) that directs viewers' eyes back to the subject, that will be even more effective!

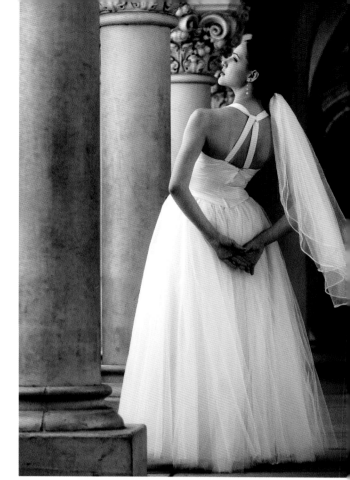

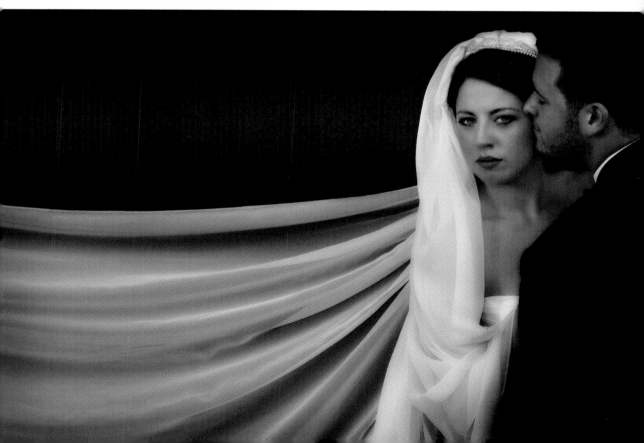

48. A HOLLYWOOD LOOK

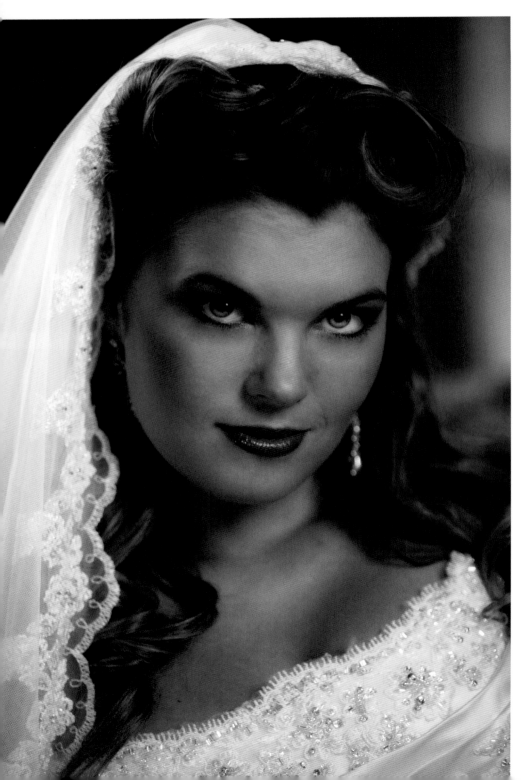

DIFFERENT POSES, SAME LIGHTING

I always strive to create a variety of looks without having to rebuild my lighting setup. These three images are good examples.

PORTRAIT 1

For the image to the left, the bride's head was tilted to camera right, toward the main light. Because I was shooting down, I made sure to check that the light was still visible as nice catchlights in her eyes.

PORTRAIT 2

Have you ever noticed how classic Hollywood starlets were often shown looking up into the heavens? Adjusting her face to this position (*top right*) created a flattering loop lighting pattern with bold accents on the back of her veil and her hair. It's a heavenly look that viewers will find mesmerizing—all without changing the lighting setup.

PORTRAIT 3

I turned her body and face slightly away from the main light for another different look (*below*). To change up the composition, I switched to a horizontal shot and left lots of negative space on the left side of the frame. I wanted to sell her a wall portrait and we need lots of open space in the composition to produce a large canvas gallery wrap.

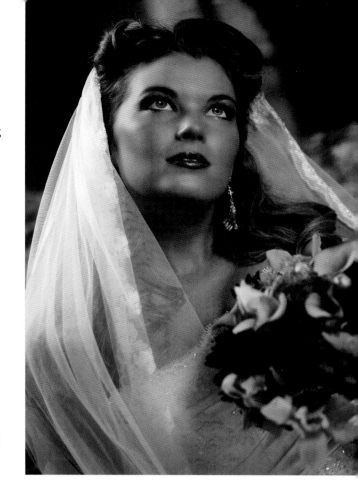

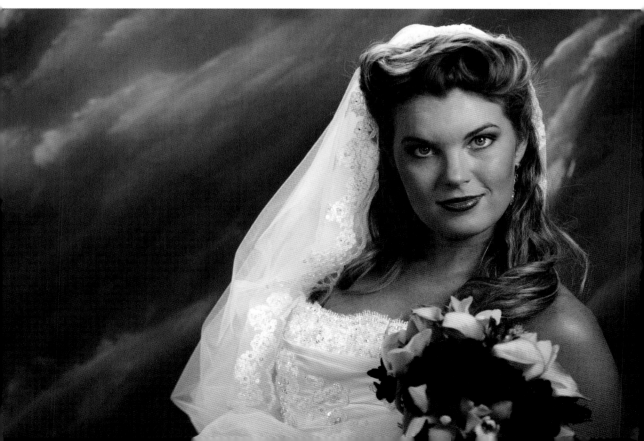

30 DAYS TO STUDIO SUCCESS

M	C	P	G	E
Create client referral wallet cards	Send ten thank-you cards to clients	Develop gift-with-purchase products	Write down ten business goals and a timeline	Read a book or watch an educational DVD
Join a network group like the chamber of commerce or BNI	Develop a customer-of-the-month highlight for your website	Create a sales presentation booklet	Create of review your mission statement	Sign up for an online class (like at rickferro.com)
Display your images in a local business	Send new clients a welcome package	Go to the mall; study how other businesses package their products	Create a list of what you are grateful for	Study other photographers' websites
Create a blog	Create a calendar for clients with sessions for the year	Create new samples for a gallery display	Do a task that you have been putting off	Find a mentor and show them your work
Create an e-mail campaign	Offer to hang your clients' framed prints	Create packaging that is unique to your studio	Target ten people that you want to meet	Practice a new technique in your studio or on location
Book and do a portrait party	Create a birthday and anniversary program (SOC)	Put a gift registry on your website	Spend tonight reviewing a list of tomorrow's goals	Visit a gallery or library and study the work of masters

49. 30 DAYS TO STUDIO SUCCESS

CONTRIBUTOR: Deborah Lynn Ferro

For just 30 minutes a day (or more, if you choose), challenge yourself to take on the items listed in the "30 Days to Studio Success" chart on the facing page. So many business owners work in crisis mode without any organization or goals in place to develop the growth of their business. This 30 day plan is designed to help you develop and work *on* your business instead of just *in* it. It is up to you to be successful and to define what that means to you. (*Note:* Since financial tasks should be done daily, they are not mentioned here.) The following are some details on each of the main categories for action.

MARKETING (M)

You may be a master photographer but 80 percent of your business is marketing and sales. Marketing showcases your brand and creates a competitive advantage. If you are not good at this, find someone who is and hire them or barter with them for an exchange of services.

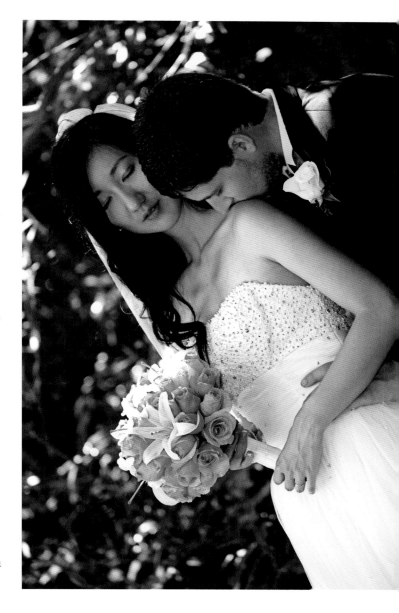

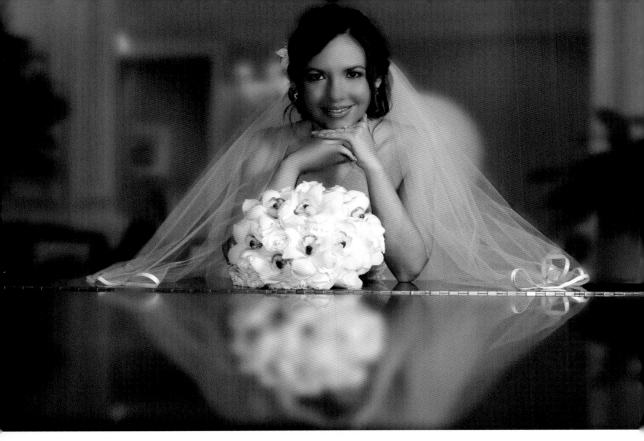

CUSTOMER SERVICE (C)

It is much easier to keep a current client than obtain a new one. That makes it critical to find ways to keep your customers coming back—and to encourage them to refer their friends to you. Clients buy for two reasons: good feelings and solutions to problems. Value plus appreciation equals loyalty!

PRODUCT DEVELOPMENT (P)

Keeping up with the latest product trends can be overwhelming, but not if you do it this way. Make sure you are in touch with what your clients prefer (jewelry, photo purses, gallery wrapped canvases, etc.). If you do not offer these items, they will find a photographer who does.

GOAL SETTING (G)

A small business owner does more in a day than a CEO does in a month. So how do we get everything done? Goals! As Denis Waitley, author of *The Winner's Edge* (Berkley, 1986), has said, "One of the best ways we can get the most from the energy we have is to focus it. That is what goals can do for us: concentrate our energy."

EDUCATION (E)

Technology changes every day. If we are going to offer our clients more than they can do themselves then we must be aggressive in learning. Instead of letting life change around us, we must be the change! Remember: success doesn't just happen—*you* make it happen!

50. ADD SOME MUSIC

CONTRIBUTOR: Deborah Lynn Ferro

Adding high-quality music to your slideshows and videos will elevate the emotion and energy. In addition to using these shows during presentations, many professional photographers now include them as a featured product in their photo packages. A promotional video showcasing your work is also one of the best ways to reach new clients on the web and on social media sites like Facebook and YouTube.

USE LICENSED MUSIC ONLY

Remember that you should only use licensed music in your slideshows or videos. It is not legal to use songs from your personal iTunes or CD collection within slideshows or videos for your business, for clients, or on social media. When you purchase a music CD at a retail store, or when you download a song from iTunes or other "consumer" music sites, you are only obtaining the right to use the music for personal listening.

As a business owner and creative professional, you should not be using anyone else's content without a license. After all, you probably wouldn't want other people making unauthorized copies of your work, either! The responsibility is yours and making the right choice is a smart way to protect your business and avoid legal issues. Besides, today it's easier than ever to license music for your projects. Websites like Triple Scoop Music make it simple to find and license great music with a few clicks.

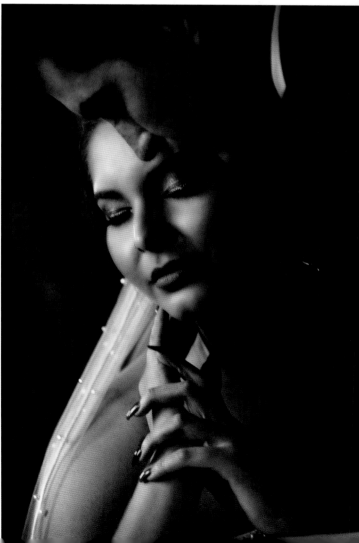

51. SOCIAL MEDIA

I am by no means a techie, but you can't be alive today and not be immersed in social media. It has become a primary means by which photographers stay in touch with their existing clients and meet new ones. Even Disney sees the advantage of Facebook and Pinterest and allows us to use our images on those sites as long as they have the Disney Fine Art Photography logo on them.

The Importance of Marketing

Most people get into photography because of their passion for creating images. However, just being able to create great images doesn't pay the mortgage. That requires solid marketing. To be successful at marketing you must have these attributes:

- Believe in yourself.
- Sell yourself.
- Create a plan, find a way to implement it, and take action.
- Be consistent—don't give up.

Finally, remember that you are in control of the quality of the images you present, the demographics of your client base, and your level of success. In the end, that is your greatest asset as a marketer. Again: success doesn't just happen, *you* make it happen!

FACEBOOK

I use Facebook to expose my work to prospective brides. There, they can see my work and interact with me quickly. Facebook has also been a good platform for me to share my knowledge with new photographers. Additionally, I am inspired daily by the amazing work I see from other photographers on social media. You can see my Facebook page at: www.facebook.com/ferrophotography

PINTEREST

I also love Pinterest because brides are constantly on the site to get ideas for their wedding planning. Often, they pin my images to share them with friends. To see my Pinterest boards, go to: www.pinterest.com/rickferro/

> ❝ I am inspired daily by the amazing work I see from other photographers on social media. ❞

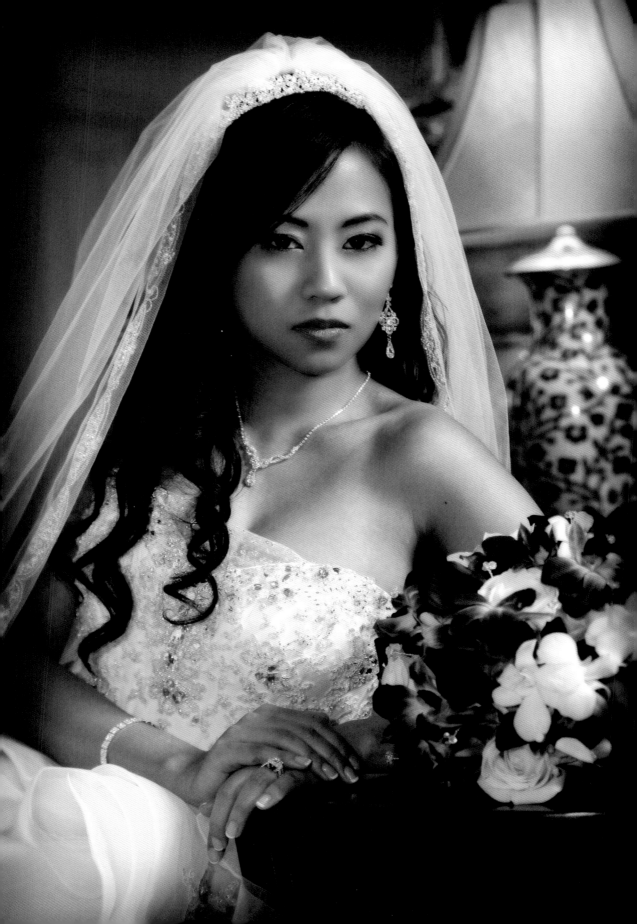

52. LUCIS PRO

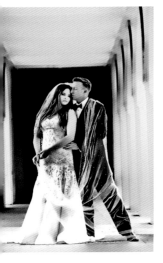
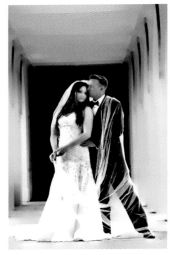

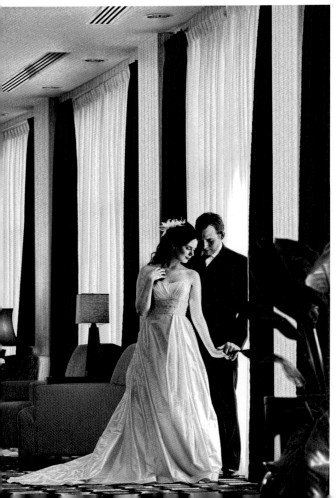

One of my favorite postproduction tools is Lucis Pro 6 SA. It is simple to use yet very powerful. Lucis enhances image detail and creates unlimited special effects using only two sliders that measure and alter differences in intensity (contrast variances) between pixels.

HOW IT WORKS

The two sliders isolate the range of contrast variances Lucis will enhance, allowing you to reveal image information throughout the frame, in the dark, light, and mid-range intensity areas. The variance in contrast is the same, whether it's in a bright or dark area of the image.

The software stretches even the smallest contrast variances so you can see all that detail everywhere. When Lucis stretches only the larger contrast variances, the image detail is diminished and the image has a watercolor effect. Lucis can also diminish the smallest and largest contrast variances (enhancing mid-range contrast variances) to create a patterned or sculpted look.

Additionally, Lucis separately enhances the intensity data in each of the image's color channels (red, green, and blue). How the intensity information in each channel overlaps determines the image's features and color. This can produce surrealistic effects.

Once an image has been processed with Lucis, all of the contrast variances are different. Therefore, processing an image a second time creates even more artistic variations.

SUBDUE THE EFFECT

Lucis also has a slider to reduce color shifts and a slider to mix in a percentage of the original image to subdue the Lucis effects. Artists can add a slight texture to make the image pop.

PRACTICE MAKES PERFECT

Technically, Lucis is easy to use. However, learning to use Lucis effectively requires playing with the software and getting a feel for how it enhances images. A digital image is a complex set of contrast variances that Lucis lets you explore. You can play with your images and create art that you had no idea was even there.

❝ Lucis enhances image detail and creates unlimited special effects using only two sliders. ❞

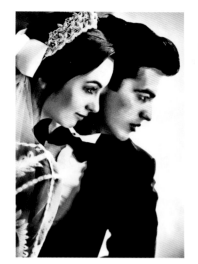
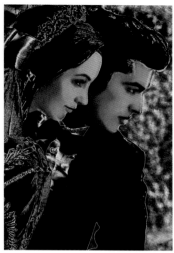
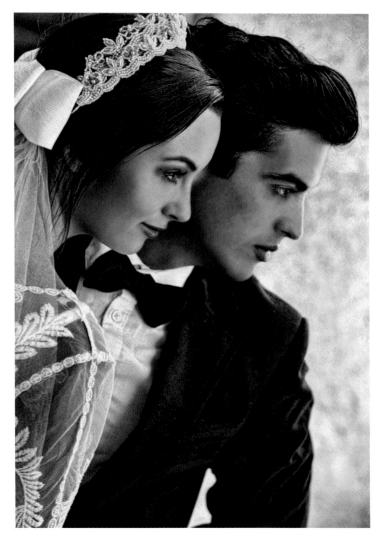

53. SMART PHONES

wanted to mention the amazing technology the next generation of photographers will be using—and the terrific new mobile products already available.

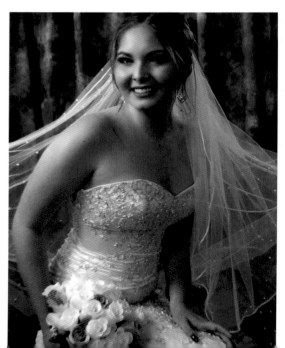

HARDWARE

Today's smart phones are already more than capable of capturing astounding quality in both still images and video. And it seems like every six months, the smart phone technology gets even better. I shoot with my iPhone mounted in a Ztylus case with a 4-in-1 lens attachment. This lets me choose from a macro lens, wide-angle lens, fisheye lens, or circular polarizing filter.

APPS

Not only is the iPhone camera's hardware amazing, but there are now also apps that really make the images cooler—Snapseed, Top Camera, 645 Pro, Movie Pro, PS Touch, and Video Shop to name a few. Best of all, they are free!

LIGHTING

There are now even LED lights that are made especially for the smart phone. I had to invest in one myself—and I can see what all the buzz is about!

AMAZING RESULTS

If I'm using my regular LED lights on a subject, I'll also shoot one or two images for fun with my smart phone. And, let me tell, you the images are sharp and really nice (see the portrait to the left).

54. **ALIEN SKIN**

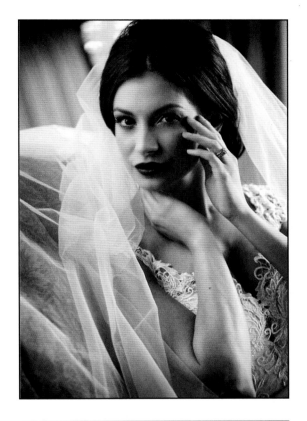

Post-processing tools can have a big impact on the feeling and mood of your image. To demonstrate this, let's look at the same image treated two different ways. I'll be using an editing program by Alien Skin Software called the Exposure X Bundle, which has a library of over five hundred different looks and editing tools fine-tune every aspect of an image. In the screen shot below, you see the presets preview panel (1), the main window (2) and the editing panel (3)

BLACK & WHITE

For my first treatment, I wanted to go for an old-fashioned black & white look, that classic vintage feel. In the presets preview panel, I chose the Kodak TRIX 400 setting. Kodak introduced this iconic

film in 1940, and it was one of their first high-speed black & white films. It's one of the most popular black & white films ever made. Photographers love it for its grain. Here, to make the grain effect a little less pronounced, I dialled back the overall grain strength to 60 percent.

To compare the current look with the original shot, I can simply click the "before" button. This is a handy way to see if I like the new look—without undoing my changes.

SOFT COLOR

For the next look, I went for a color treatment that differs subtly from the original shot. I chose the Kodachrome II (1962–1974) preset option. Kodak introduced this film in 1961 as an improvement to its famous Kodachrome line. Until it

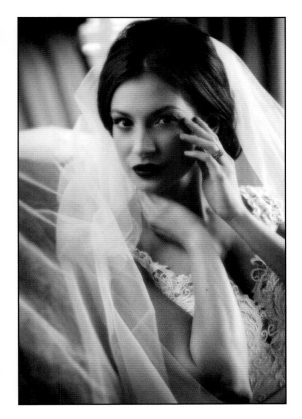

open on a fast lens, like a f/1.4 or f/1.8. Using bokeh can be an effective way to brings the viewer's attention to your subject. I chose the radial shape option.

Then I adjusted the circular focus region to keep my subject in focus, and adjusted the amount to 8 percent.

If I had wanted to achieve a look that was somewhere in between that of the original color shot and the Kodachrome II look, I could also have adjusted the overall intensity slider to create a blend. This is a nice option if you're looking to get a blend between your original and results achieved using the exposure preset. In this case, however, I liked the Kodachrome II look, so I kept the slider at 100 percent.

KEEP EXPERIMENTING

One of the fun aspects of using a product like the Exposure X Bundle is how much experimenting you can do with different looks and adjustments. You can play around with lots of different styles, and if you really like the results you can save them as custom settings to be used on other photos.

Postprocessing work is often a big part of developing a signature style, so it pays to become familiar with the tools available. To learn more about The Exposure X Bundle, visit www.alienskin.com. (They offer a 30-day free trial if you'd like to try it first.)

was discontinued in 2010, Kodachrome was a favorite of many photographers, who praised it for having a "poetry, softness, and elegance."

Notice how this preset brings out the shadows and pops the saturation levels. It's great if you want to warm up the skin tones just a bit.

I also made two other adjustments. First, I softened the focus just a bit using the Focus > Glamour Shot Medium setting. This works well when you want a slightly softer look, which can be flattering to the skin.

Next, I applied a subtle bokeh effect. Bokeh is a type of blur that is caused by the parts of an image that are out of focus, and is usually the result of shooting wide

INDEX

Wedding Photography Kickstart

Pete and Liliana Wright help you shift your wedding photo business into high gear and achieve unlimited success! *$37.95 list, 7x10, 128p, 180 color images, index, order no. 2096.*

Sikh Weddings

Gurm Sohal is your expert guide to photographing this growing sector of the wedding market. With these skills, you'll shoot with confidence! *$37.95 list, 7x10, 128p, 180 color images, index, order no. 2093.*

Senior Style

Tim Schooler is well-known for his fashion-forward senior portraits. In this book, he walks you through his approach to lighting, posing, and more. *$37.95 list, 7.5x10, 128p, 220 color images, index, order no. 2089.*

Shot in the Dark

Brett Florens tackles low light photography, showing you how to create amazing portrait and wedding images in challenging conditions. *$29.95 list, 7x10, 128p, 180 color images, index, order no. 2086.*

Stylish Weddings

Kevin Jairaj shows you how to create dramatic wedding images in any setting—shots that look like they were ripped from the pages of a magazine! *$34.95 list, 7x10, 128p, 180 color images, index, order no. 2073.*

Portraiture Unleashed

Travis Gadsby pushes portraiture in exciting new directions with design concepts that are sure to thrill viewers—and clients! *$34.95 list, 7.5x10, 128p, 200 color images, order no. 2065.*

Epic Weddings

Dan Doke shows you how he uses lighting, posing, composition, and creative scene selection to create truly jaw-dropping wedding images. *$34.95 list, 7x10, 128p, 180 color images, order no. 2061.*

Cinematic Portraits

Pete Wright shows you how to adapt classic Hollywood lighting and posing techniques to modern equipment and portrait sessions. *$34.95 list, 7.5x10, 128p, 120 images, order no. 2057.*

The World's Top Wedding Photographers

Ten of the world's top shooters talk with Bill Hurter about the secrets of their creative and professional success. *$27.95 list, 7.5x10, 128p, 240 images, order no. 2047.*

Portraiture Unplugged

Carl Caylor demonstrates that great portraiture doesn't require a studio or pricey gear. Natural light can give you outstanding results! *$27.95 list, 7.5x10, 128p, 220 color images, order no. 2060.*